SKETCH BOOK

© 2009 by Rockport Publishers, Inc.

First published in the United States of America by
Rockport Publishers, a member of
Quayside Publishing Group
100 Cummings Center
Suite 406-L
Beverly, Massachusetts 01915-6101
Telephone: (978) 282-9590
Fax: (978) 283-2742
www.rockpub.com

Library of Congress Cataloging-in-Publication Data
O'Donnell, Timothy.
Sketchbook : conceptual drawings from the world's most influential designers and creatives / Timothy O'Donnell.
 p. cm.
 ISBN-13: 978-1-59253-521-7
 ISBN-10: 1-59253-521-6
1. Artists' preparatory studies. 2. Design. I. Title.
N7433.5.O36 2009
745.4—dc22

 2008041595
 CIP

ISBN-13: 978-1-59253-521-7
ISBN-10: 1-59253-521-6

10 9 8 7 6 5 4 3 2 1

Designed by Timothy O'Donnell
Typeset in Futura, Clarendon, Scala, and Akzidenz Grotesk

Printed in Singapore

SKETCH BOOK

**Conceptual Drawings from the
World's Most Influential Designers**

Timothy O'Donnell

BEVERLY MASSACHUSETTS

ROCKPORT
PUBLISHERS

Contents

"To draw oneself, to trace the lines,
handle the volumes, organize the surface . . .
all this means first to look, and then
to observe and finally perhaps to discover . . .
and it is then that inspiration may come."

Le Corbusier
Le Corbusier: My Work

Introduction

Michael Bierut

Rob O'Connor

Author's collection

Paperback Sketchbook

CREATIVES THE WORLD OVER use nearly identical hardware, software, and cuts of typefaces. Design magazines, annuals, and blogs all present the work respectfully laid out and captioned as if a museum piece. Often divorced from the projects' history or any sense of context, a designer can appreciate the style of the work but only wonder at the process of its creation. By appearing (often simultaneously) across these media, the work of a celebrated few immediately informs the choices of thousands; resulting in a deluge of similar-looking work in which the originator's rationale is hidden. In this computerized environment, which has so many obvious benefits, the eventual disappearance of physical sketching from the creative's work life seemed inevitable—and yet, sketching in some form remains an integral part of the creative process.

Why? For one thing, privacy. A sketchbook allows secrets. A designer's joy at receiving a 30-inch (76.2 cm) monitor sours rapidly when he realizes his work is visible from across the studio; work becomes instantly public and open to critique in the project's infancy. Where designers were once kept apart from the "suits," as more companies begin to recognize the business value that good design can provide, they now sit at the same table. And so they are exposed even earlier to budget constraints, market demands, and the expectations of the client. Sketchbooks, like diaries, allow the designer a private, personal space to vent, daydream, free associate and explore. Most importantly, they offer a place where mistakes are allowed and experimentation encouraged. With the pressure of the marketplace removed, the sketchbook offers freedom. We might hesitate to raise our hand in a brainstorming session for fear of appearing foolish; there is no idea too trite or cliché to be scrawled into a notepad. As Stefan Bucher

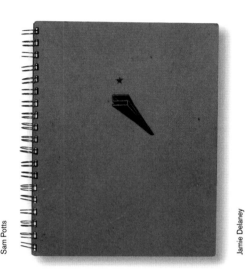

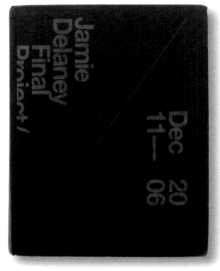

Jamie
Delaney
Final
Project /

Dec
11—

20
06

Exercise Book

remarked during his talk on creativity at the 2008 How Design Conference, "When Lindsay Lohan screws up, it's going to be in the papers. The beautiful thing about graphic design is that your failures are private—people are only going to see what you want them to see." In the unstructured playground of the sketchbook, we can mull ideas over at our leisure, scratching out or erasing anything that doesn't hold up to closer scrutiny, or editing and reworking the ideas that merit further exploration. Sketching represents a pure phase of creativity, an exciting phase unencumbered by limitations, when any idea is valid and worth investigating.

Sketchbooks also serve as repositories of information or archives of ideas. Their obvious utility in storing ideas aside, of equal importance to the designer is the way the physical act of drawing or writing an idea seems to cement it into our consciousness. In the recent exhibi-

tion "IDEO Selects: Work from the Permanent Collection at the Cooper-Hewitt National Design Museum," the guest curators selected two pieces of sketched or preparatory work, one of which was the sketchbook of Funny Garbage founder Peter Girardi. In the exhibit's notes, Girardi says "The best way I've found to remember ideas and concepts is to render them I spend some time drawing them, and they stick in my head."[1] Nor is this practice limited to people working in the creative sphere—Dan Roam, in his book *The Back of the Napkin: Solving Problems and Selling Ideas with Pictures*, recalls, "I've worked with a CEO at a global consulting company who draws everything out on sheets of tabloid paper as his way of thinking through a problem."[2]

This book is not intended as a polemic against the computer and the evils of technology; having tasted the power and speed of the computer, few among us would wish to be hunched

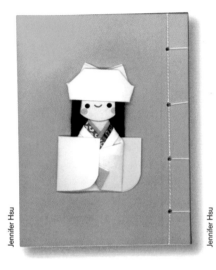

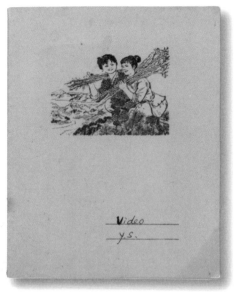

Video
y s.

over drawing boards or wrestling with character counts. However, it is undeniable that the price we have paid is a degree of homogenization in our work. As author Adrian Shaughnessy puts it, "Today, thanks to speed-of-light microprocessors and do-everything software, we all design in the same way: We sit lifelessly, only our wrists moving, as we stare at a screen. Our focus has narrowed—we avoid anything that can't be done on the computer. The screen dictates our relationship to our work—it dictates how our work looks."[3]

On this technologically level playing field, our individuality and unique approach can be obscured. A designer's sketches—whether tight, comprehensive layouts in a leather-bound book or loose scrawls on the back of a napkin— provide an important and illuminating insight into their influences, methods, and worldview.

Psychology professor Mihaly Csikszentmihalyi, best known for his research into flow—the mental state we often refer to as being in the zone—calls notebooks "caches of experience" and the "raw material" from which much creative work originates.[4]

Designers have a voracious appetite for visual stimuli; students particularly begin to define themselves creatively by assimilating the work they see in books, magazines, and websites. This book offers encouragement as well as inspiration, in contrast to the sometimes intimidating annuals which make it look effortless. Saul Bass once noted in an interview: "[Students] are not privy to process. They may have the illusion that these things really spring full-blown out of the head of some designer. This is a very unsettling perception for young people, because they struggle with their work.

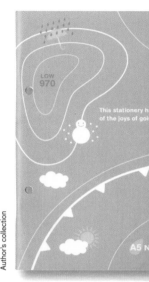

Sam Potts

Sam Potts

Sam Potts

Author's collection

They have a go at it …. They redo …. It gets better …. It slips …. It gets worse …. It comes back …. It comes together. And maybe it's something that's pretty good, even excellent. But they say to themselves, "Gee, it seems hard and it's so difficult. Am I really suited for this?"[5]

The process to which Bass referred is largely a story of trial and tribulation—of feeling one's way blindly toward a solution. *Sketchbook* is an attempt to lay that process bare. Of course, it's impossible for anyone to fully understand another's thoughts. But by glancing into the origins of some acclaimed projects, from typeface design to architecture, photography to music packaging, the reader can glean inspiration from the thought behind these projects. By doing so, he takes a further step toward developing his own voice, and providing the inspiration for those that follow.

HOW TO USE THIS BOOK

Sketchbook delves deep into the creative process, giving a rare behind-the-scenes view into the design thinking of many of today's leading figures. Sketchbooks can be fascinating and often beautiful pieces of ephemera in their own right, but their true importance lies in the ideas they contain. There is no glossy execution to distract from a lack of ideas—sketchbooks are *all about* ideas. Throughout, the designers provide commentary, explaining in detail the realities of the creative process—the struggles, the moments of writer's block, the tangents that went nowhere and those that led to an exciting new direction.

TOPAS GRAPH

TOPOS GT

Rough

"Sketching is like haiku; with a few lines you can represent grand ideas."

Ayse Birsel
author interview, June 2008

Jason Munn /
The Small Stakes

Oakland, California

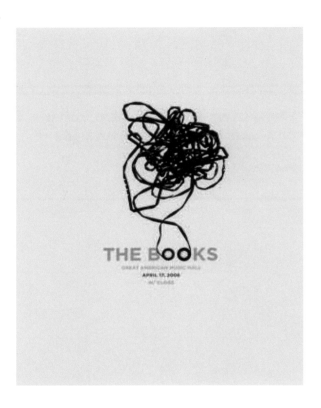

The Small Stakes has been producing nationally and internationally commissioned book covers, album packaging, and screen-printed posters since 2003. In addition to many well-known bands, Jason Munn's clients include Random House, ReadyMade magazine, and Patagonia.

"I CAN'T JUST JUMP on the computer," says Jason Munn. "Some people can, but I can't start anything until I have somewhat of a plan."

Munn's studio in Oakland, California, has two desks—one with a computer, and one without. "Even though the computer's only across the room, it helps not being right in front of it. Otherwise, every time I get an email, I have to look at it immediately, and I can definitely waste a lot of time on the Internet.

"Typically, I spend half my time sketching," he says. "I'll often start off with a list of word associations. My sketchbooks are kind of a mess in general; I keep everything in there, to-do lists, receipts, reminders for appointments, etc."

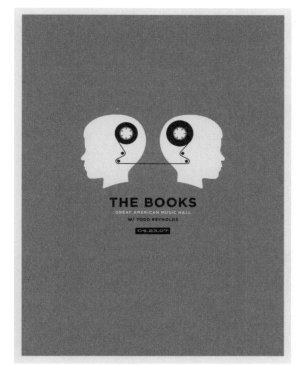

"*The Books* is two guys who play cello and guitar; they rummage through garage sales and thrift stores for old cassettes and answering machine tapes, and then they record their own music over it. It's super, super intricate. I had done my first poster for them almost exactly one year before, and I had used an image of an unwound cassette, because my assumption was that the place where they recorded their music would be a huge mess, with old tapes piled all over the place. When it came to doing the second poster, I discovered they're actually very precise about it; they have a whole process of naming and cataloging everything, so they can find it again.

I wanted to make the second poster similar, so they'd relate to each other, so I used the same silver and black palette, and I used cassette tape imagery again, although much more neatly this time."

—Jason Munn

Once he's sketched an idea he likes, Munn tries it out in Illustrator to see if it works, often going back and forth between the computer and his sketchbook. If the idea shows promise, he moves onto tracing paper. "I'll just keep working over it, tracing on top of the drawing. This is where I'm really figuring out the details."

One area Munn rarely explores in his sketchbooks is typography. "I might sketch out where it's going to go, but I play around with the fonts on the computer." Despite his reliance on working out ideas on paper, he admits to occasionally trying to design on the screen. "Sometimes I will get lucky on the computer and see things I hadn't seen in the initial thumbnailing. But in general, I'll just sort of flail about and not really get anywhere. That's just the reality of it."

Ted Leo + Pharmacists
Poster

"Ted Leo is somewhat political and I wanted to reflect that, but I didn't want to use, you know, fists in the air. I was thinking about how else I could use war imagery. I was playing with bombs and flowers, but everything started looking like vases. Then I realized the bomb could work as a birdcage. Occasionally it bothers me because I think it looks like a rocket, not a bomb."

—Jason Munn

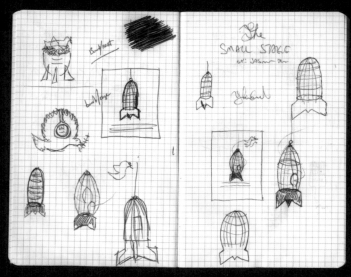

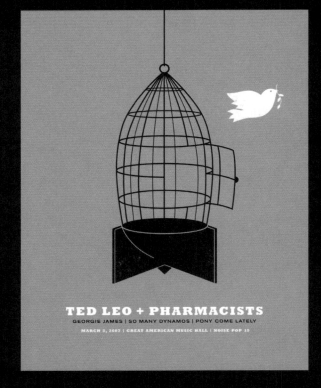

TED LEO + PHARMACISTS

GEORGIE JAMES | SO MANY DYNAMOS | PONY COME LATELY

MARCH 2, 2007 | GREAT AMERICAN MUSIC HALL | NOISE POP 15

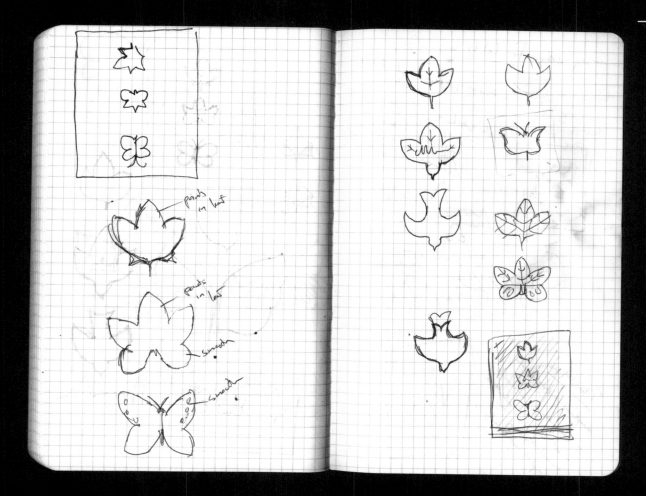

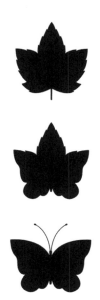

JENS LEKMAN with THE HONEYDRIPS on MARCH 22, 2008 at BIMBO'S 365 CLUB

Jens Lekman
Poster

"I was inspired by one of Jens' songs, called "*Maple Leaves*," in which he's talking to a girl, who says 'We are all just make-believe,' and he thinks she said 'We are all just maple leaves.' So I played with the idea of thinking one thing is actually another. I seem to use a lot of butterflies; maybe because they're symmetrical."

—Jason Munn

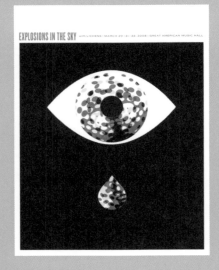

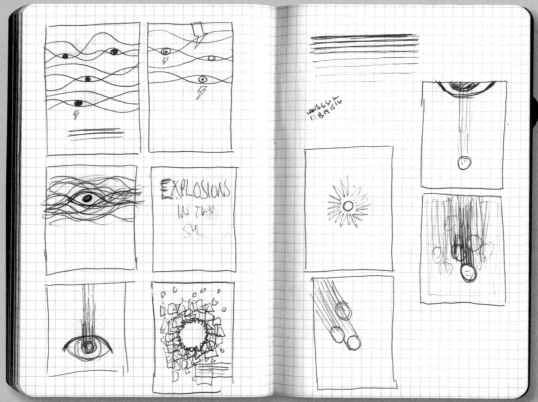

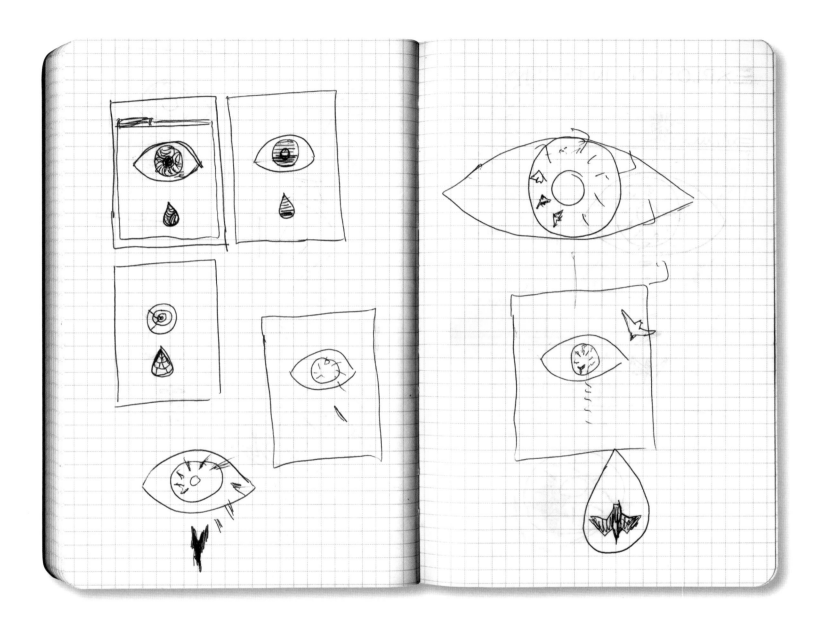

"This reminds me of an old science fiction book cover. I was thinking about the band's name, and fireworks came to mind. I had tried a ton of sketches for this, with birds and lightning bolts, but nothing was working."
　　　　　—Jason Munn

Modest Mouse
Poster

"The title of Modest Mouse's most recent album was *We Were Dead Before the Ship Even Sank*, which obviously lent itself to the ship imagery. I brought back the eye image I'd used on the 'Explosions in the Sky' poster. I used to try to steer away from repeating myself, but now I really enjoy trying to create a visual language I can work with."
—Jason Munn

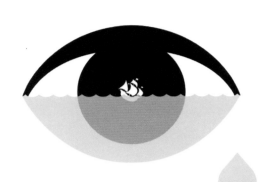

MODEST MOUSE WITH MAN MAN __ NOVEMBER 30, 2007 __ KZOO STATE THEATRE

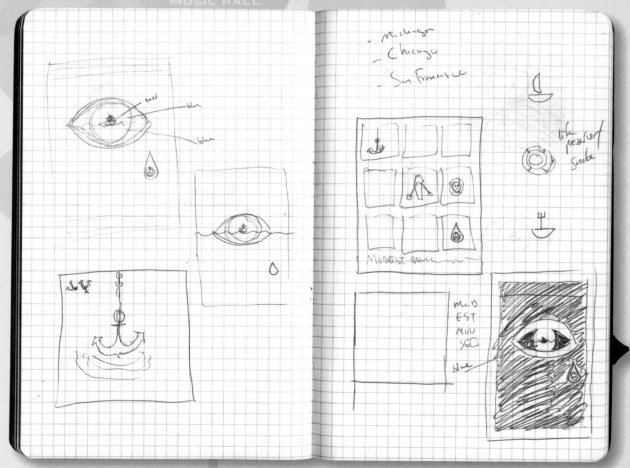

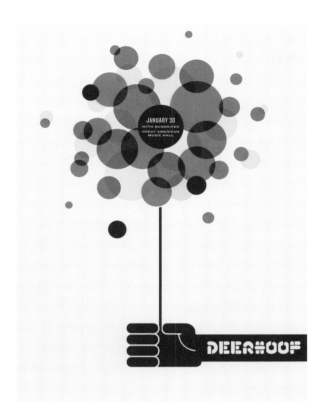

Deerhoof
Poster

"Deerhoof is kind of an abstract band, unconventional, and hard to classify. Sometimes I'll have a hard time finding an image for bands like that, and eventually I'll just say, 'Oh, dots!' They have a poppy kind of sound that just seems to want really bright colors."
—Jason Munn

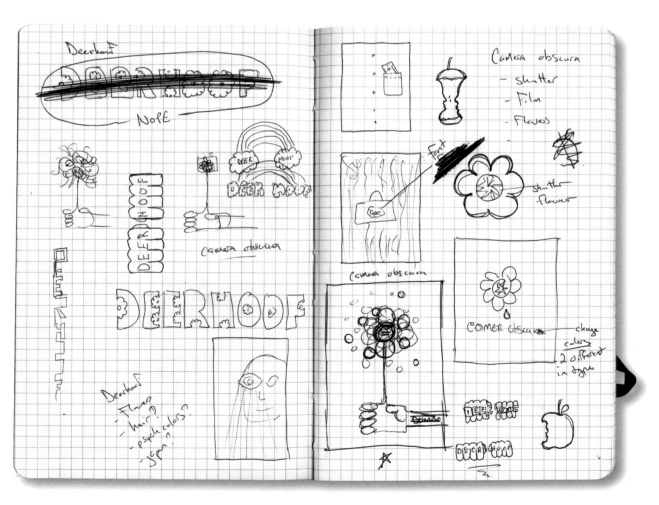

Daljit Singh / Digit

London

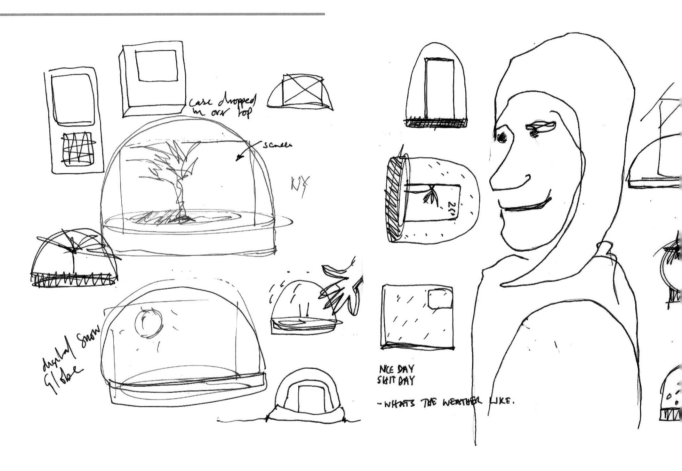

Daljit Singh is executive creative director and founding partner of Digit, one of the world's longest-established digital agencies, Digit has worked with leading brands—Nokia, Shell, the London 2012 Olympics, and Unilever—to create award-winning interactive environments and content punctuated with humor and personality. Digit uses digital communications channels to connect brands to consumers, surprising and delighting through interaction.

A DIGIT MOTTO is that communication is about people, not technology, as evidenced by its core values: "Simple. Human. Interaction." "This is extremely fundamental to our process," says Singh. "We're interested in humanizing technology, perhaps even making it look a little bit silly.

"Interactivity is quite difficult to translate into a two-dimensional sketch," Singh admits. "Very few people work in the digital environment sketch; they largely go straight to the screen. I always encourage people to actually make a mark on paper; the rigor and process of drawing really helps—you're not relying on a technique or a plug-in. It's purely based on thinking.

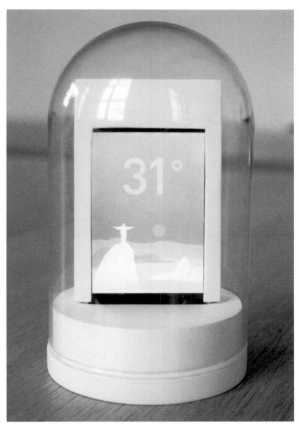

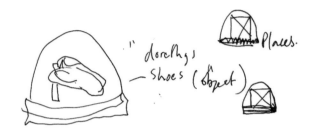

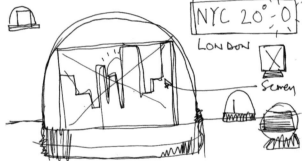

"I tend to sketch for myself, just to express the way I think. My sketches are quite rudimentary. Sometimes I do two or three sketches, sometimes I'll produce reams and reams, in an attempt to explain an idea.

"If you spend time sketching, it's really quite powerful. You end up with something much more solid at the end of the project."

"Since Digit began, we've always committed 10 percent of our time to self-initiated projects. This project was born out of an internal conversation about creating digital souvenirs—like the souvenirs you buy for their kitsch value. We thought, 'Wouldn't it be great to take something as iconic as a snow globe and make it intelligent?' It was an opportunity to take technology and apply it to something familiar. When you pick up and shake the digital snow globe, it displays the current weather in one of fifteen cities."

—Daljit Singh

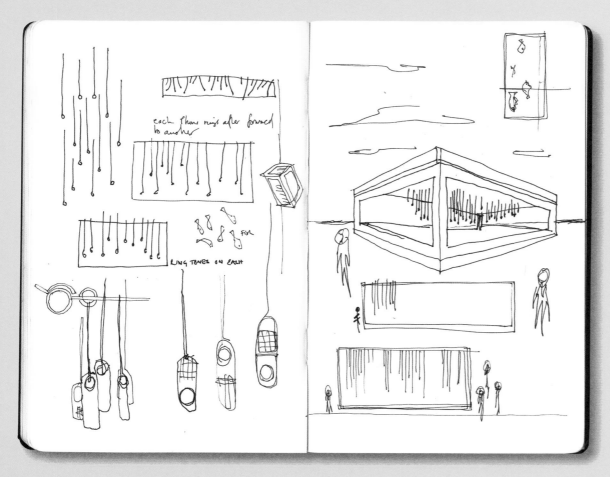

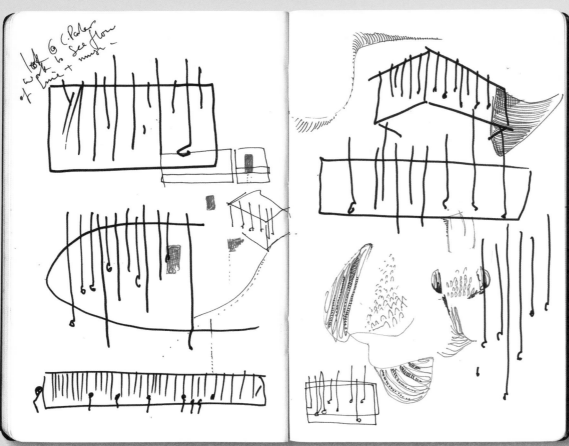

"The Digital Aquarium is a piece developed out of a conversation with Alice Rawsthorn, who at the time was the director of the Design Museum in London. They have an exhibition space called The Tank, which is essentially a glass tank overlooking the south bank of the Thames, and Alice asked me if I wanted to do something with it.

I'm a massive fan of the artist Cornelia Parker and her extraordinary exploded shed piece. The 1991 installation *Cold Dark Matter: An Exploded View*, consisted of a garden shed and its miscellaneous contents, which had been literally blown up by the British Army. The pieces of the exploded shed were hung as if in mid-explosion in the shape of a cube, and I thought it'd be fabulous to make a digital version. I've also always had a passion for fish and aquariums.

I approached our client, Motorola, and said, 'I'd like to hang 150 of your phones in a glass tank.' Their first thought was that I was completely mad, but they went along with it. Even though Digit at this time employed about 35 people, I ended up doing this one myself. I programmed each phone with a different ringtone, and the phone numbers appeared on the outside of the cube. When you dialed one, the phones lit up in sequence and looked like a shoal of swimming fish. The idea really comes back to our company philosophy, which is humanizing technology."
—Daljit Singh

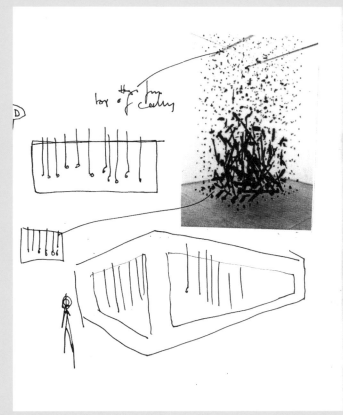

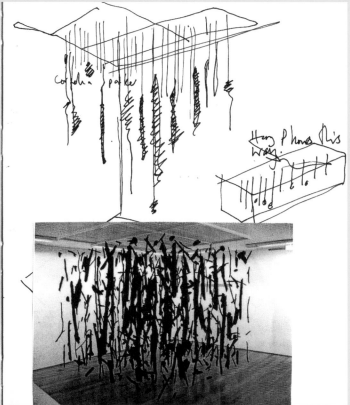

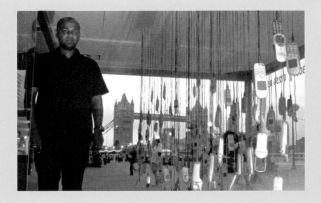

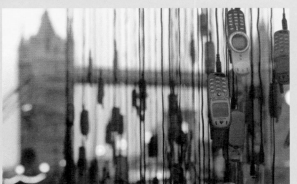

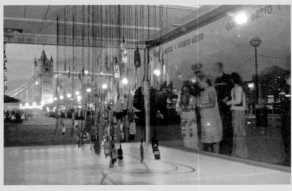

Richard Niessen /
Niessen & DeVries

Amsterdam, The Netherlands

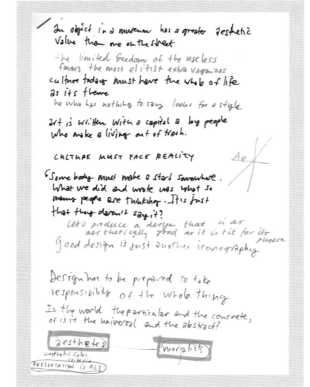

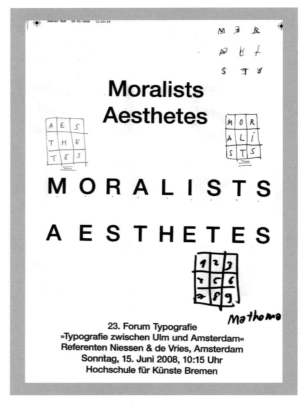

Before forming Niessen & DeVries with Esther DeVries in 2005, Richard Niessen described his work as "typographic masonry"—an apt representation of his richly layered, almost architectural approach. In their projects as a duo, they continue to explore "the tension between structure and going overboard" for clients including the Stedelijk Museum, the Dutch post office, and French railways SNCF.

SKETCHING FULFILLS MANY roles: It can serve as an outlet for excess creativity or provide a repository for ideas too good to risk losing. In Niessen & DeVries's work, where formalist rigor collides head-on with areas of intense pattern and multilayered information, sketching acts as an organizational tool, helping the designers manage overlapping layers of communication and work out production details. Niessen refers to creating "a distinct language [or a] secret vocabulary" within his design work; his sketches are a vital link between his ideas and the final piece.

"We start with some hand sketches, then we try to work things out a little bit on the computer and we

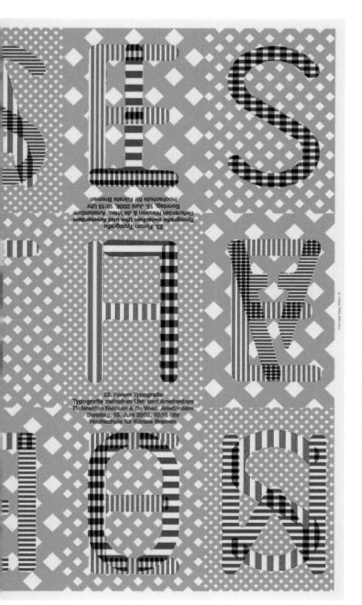

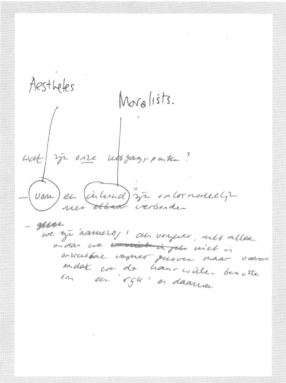

**Between Ulm
and Amsterdam
Poster**

Forum Typografie

develop it from there, drawing on top of printouts and ping-ponging between screen and hand. I could never work only on the computer; the brain–hand link is very important. At least it is to me, as I only started working on the computer when I was 23."

Though he acknowledges his sketches have a certain charm, Niessen prefers the finished piece to the drawing that spawned it—not surprising in work that so exuberantly celebrates unique materials and production techniques. "But what gets lost along the way," he says, "is the personal hand, and lately we're trying to keep that in the work, as we gain more confidence in our drawings."

"On June 15, 2007, we gave a lecture in Bremen at the Twenty-Third Forum Typografie. The theme was 'Between Ulm and Amsterdam.' We had never heard of Ulm (a German design school of the 1960s), so to do something with the theme was difficult. We started reading about Ulm in preparation for designing a poster. For us, Ulm came down to a battle between aesthetes and moralists. We think that in our work, the two blend. That's why we made a poster with both words, which can be hung in two ways."
— Richard Niessen

slingers?

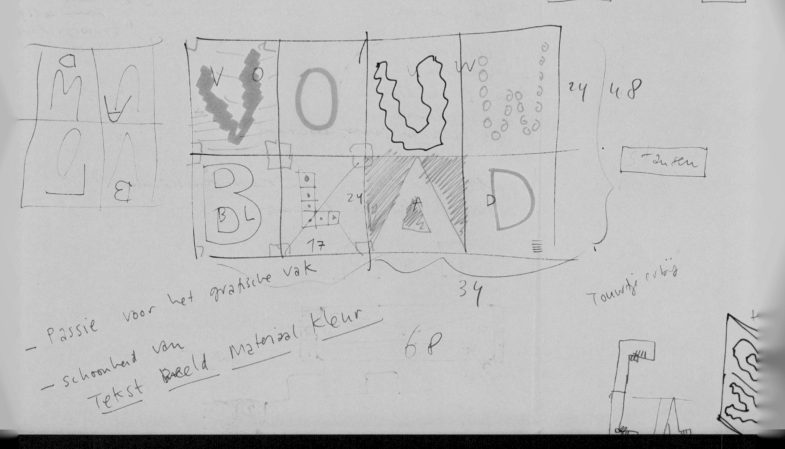

24 48

5 2u 8cu

Touwtje erbij

34

68

- Passie voor het grafische vak

- schoonheid van

Tekst Beeld Materiaal kleur

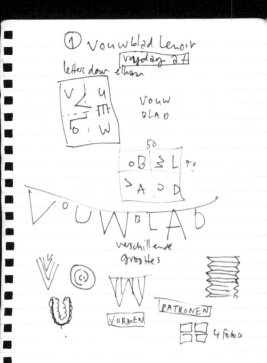

① Vouwblad Lenoir

vrijdag 27

letter door elkaar

VOUW
BLAD

50

OB ∑L 70
∋A OD

VOUWBLAD

verschillende
groottes

VORMEN PATRONEN

4 fotos

Vouwblad #4
Periodical

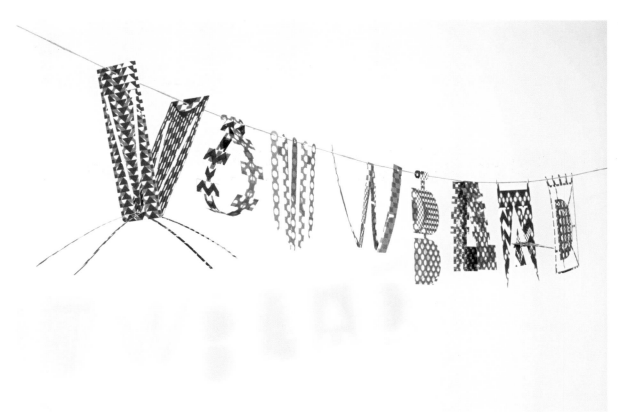

"*Vouwblad* is a series of publications that visualize the passion within the graphic industry and show the beauty the combination of text, image, materials, and color can produce. This series is an initiative of LenoirSchuring printers in Amstelveen, The Netherlands. The size of the print sheet is always the same: a little less than 50 × 70 cm, folded twice. We were asked to design *Vouwblad* No. 4, and for us, the visualization of this passion resulted in a festoon of the characters V-O-U-W-B-L-A-D. The characters themselves and the patterns used on them are taken from our collection of inspirational photographs: floor tiles, architecture, game boards, street signage, and of course festoons. Those photographs are printed on the inside of the envelope in which the festoon was sent."
—Richard Niessen

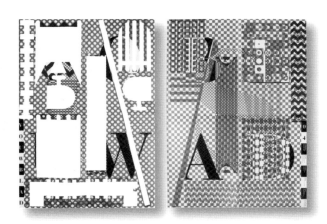

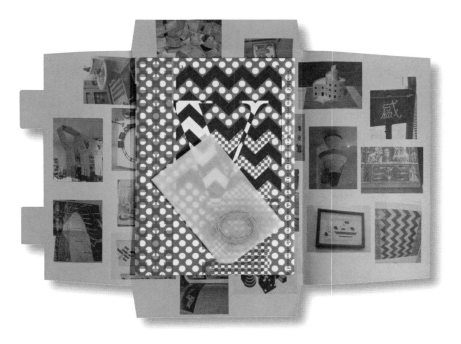

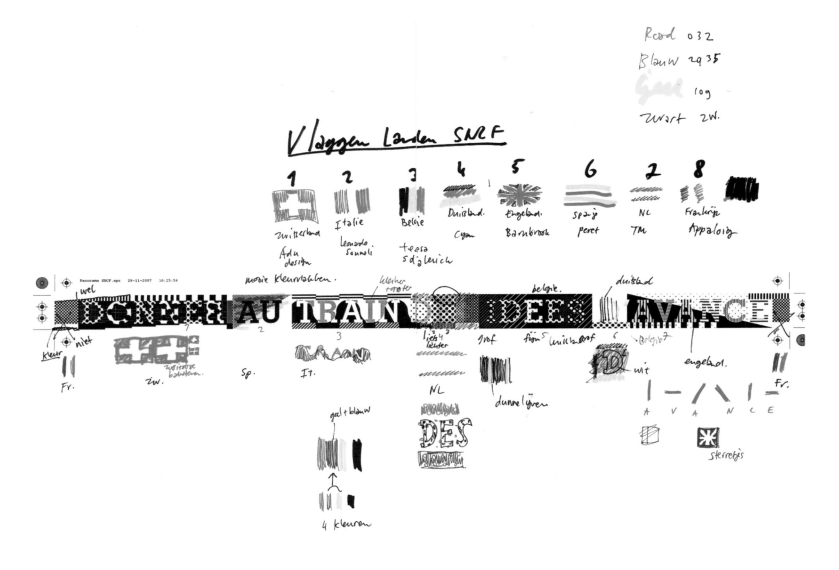

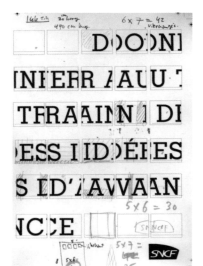
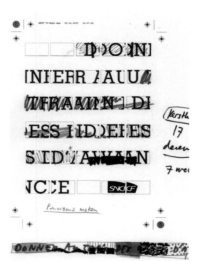

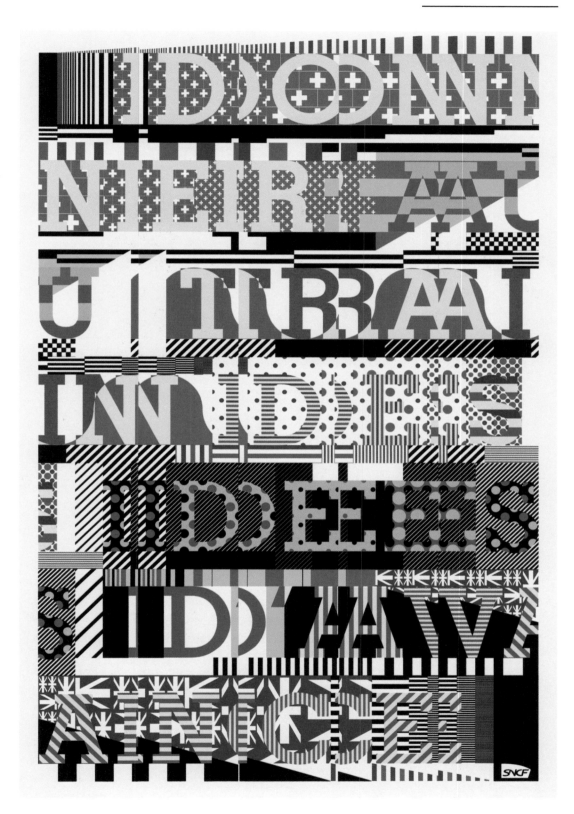

SNCF 70th Anniversary Poster

"In 2007, we designed this poster for the French railways SNCF to celebrate their seventieth year of existence. From each country the train services—Switzerland, England, Germany, Holland, Belgium, Spain, Italy, and France—a designer was asked to create a poster to be exhibited in the Grand Palais. We decided to use the phrase *Donner au train des idées d'avance* ('Think of the train first') and to make a panorama of it. The poster shows the panorama through a window of the train, like a movie, frame by frame, passing by. We used the colors and the patterns of the national flags of the eight countries for the eight words in the slogan."

—Richard Niessen

Marco Fiedler /
Vier5

Paris

"Most of the time, the drawing or sketch has nothing to do with the finished project; the drawing is more a note for an idea about how we could start. We use drawings to give instructions to the people we work with, like the printer, for example, or the atelier who does our ceramic work.

For us, it is important to draw by hand. It's the most direct way to express an idea in an artistic way. It is a beautiful thing to look at a drawing some years later and to know exactly the feeling you had when you did it. The computer is a new phenomenon. It's interesting, but it can also be boring. Drawing by hand allows your work to change a lot—and you can do it anywhere."

—Marco Fiedler

Marco Fiedler and Achim Reichert's output as Vier5 is simultaneously classically based and forward-looking. Their bespoke, project-specific fonts fuse a traditional commitment to craft with the desire to create individual, creative statements, resulting in work that looks like no one else's.

"WE ALWAYS WORK on paper," says Fiedler. This might seem at odds with their challenging work and commitment to being "modern"—a commitment that has led them to create their own typefaces because, in their view, you can't pair a modern image with older letterforms. However, digital though their work may appear, closer inspection reveals a humanist, organic approach. In a Design Observer post, Dmitri Siegel noted that Vier5's visuals were "stretched and inconsistent in a way that a computer would have to be coaxed into rendering," that despite their digital influence, their execution is not dominated by the technology.

"All the projects we did for 'Documenta 12' ('Documenta' is an exhibition of modern art, founded in 1955, that takes place every five years in Kassel, Germany) started with small sketches. In the middle of the process, while all the information was pouring through the whole team—about 200 artists and 400 projects, eight exhibition sites in 100 days—we decided in a meeting with the board that a simple form for the orientation system was needed. So during the meeting we sketched a form that later became the ceramic hills, an important part of the guiding system.

Currently, we're sketching for an orientation system in Bretigny, a suburb of Paris. We want to put cultural activities such as theater, art galleries, and cinema, into the daily lives of the people living there and to increase the possibilities for them. That project only started four days ago, so it's just beginning."

—Marco Fiedler

In keeping with their forward-looking mindset, however, the duo avoids any tendency to refer to the past by not keeping sketchbooks. "Even when we were at university, we never understood why people used books. We don't want to see some old stuff we did a few days before and to be unhappy about it. When we've tried to use sketchbooks, we always had the desire to make a perfect book and to correct the sketches later. We just find it more practicable to draw on single sheets and collect the results later," says Fiedler. "We never talk about what we want to do. We each either write some text or make a small drawing, and then we show it to each other and say, 'Please look at this, we could do this,' and then we do it."

Interestingly, the designers use their rough sketches for actual client presentations. "We never do a presentation on the computer. We mostly present in a very rough, classical way and just present a drawing. Most of the time we throw these drawings away, but if they have some artistic merit, we keep them for our archives."

Gary Baseman / HotChaChaCha, Inc.

Los Angeles

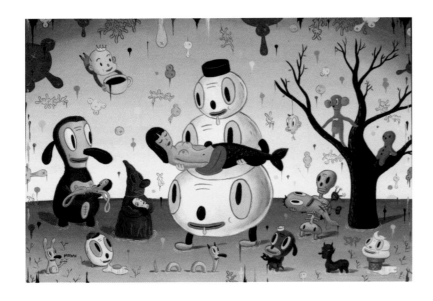

alter ego, the EVIL GENIUS. ~~body my~~ His form identical to ~~the~~ the snowman, but his body is made of flesh and blood and skin, which pulsate and rush through his body. Where the SNOWMAN'S DESIRE allows him to sacrifice himself, the EVIL GENIUS, will devour ~~the~~ his LOVE, EAT HER. ~~taken steak. her crack~~ LIKE A SHARK.
These ~~simple~~ childlike story book paintings are truely an adult allegory about man's desire and battle between love and the flesh. Longing for the female form. Accept-ing and allowing one's desire from a far and temptation of getting too close.

Summarizing Gary Baseman's career to date is an exhausting task. Named one of *Entertainment Weekly* magazine's "100 Most Creative People in Entertainment" in 2002, the self-proclaimed "pervasive artist" (in his definition, one who uses every outlet possible) has created the artwork for the best-selling game Cranium, countless illustrations for major corporations and publications, the Emmy award-winning television series *Teacher's Pet*, highly sought-after toys and collectibles, and much more. Increasingly at home in the fine art world, Baseman's work is part of the permanent collections of the National Portrait Gallery in Washington, D.C., and the Museum of Modern Art in Rome.

GARY BASEMAN IS a well-known sketcher, given to pulling out his sketchbook in restaurants or wherever he happens to be when the desire strikes. "I have a sketchbook with me 24 hours a day," he says.

Each of Baseman's sketchbooks begin with hand-painted covers that represent "where I am in my life." Inside, they teem with writings and drawings of his trademark characters. A recent *Nylon* magazine profile dubbed them "creepy-cute" (Samantha Gilewicz, May 2, 2008), an apt description, considering Baseman cites both Warner Brothers cartoons and Hieronymus Bosch as key influences. Skeletons, peg-legged rabbits, and a half-girl, half-deer named Venison are just a few of the residents of his surreal landscapes. "Sketching allows your subconscious to escape onto the paper,"

The skeletons and ghost like figures, who to resemble klansman, depict the darker nature of man. The skeleton — mortality, that we don't really have much time on this earth. The ghosts those shadow-selves are out willing to grab, pull, touch the unattainable infinity girls.

Other paintings represent the etherial nature of this world. The manifestations of desire are these bubble like entities. They ooze, gurgle, replicate, like ———. Bubbles form from other bubbles. They are all [struck] around us. They duplicate more rapidly with increased longing.

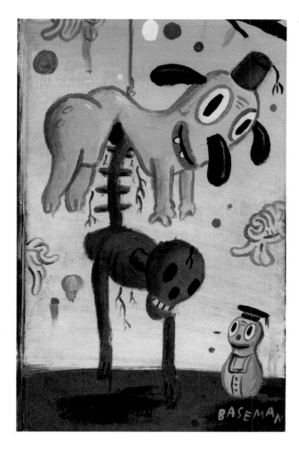

he says. "I'll just draw away and not really think about what I am doing, and I always surprise myself with what I've created. Then I'll look at what I have put down on paper after the fact and make sense of it. When I used to be an illustrator, I used to sketch out ideas; as a painter, I allow my ID to roam free and try to find simple truths about the human condition."

At the time he made the sketches shown here, Baseman recalls going through a transitional phase. "I was giving up most of my traditional art jobs and was finishing up production on *Teacher's Pet*. I was also having trouble in my marriage and found myself longing for unattainable beauty. I began to draw mermaids and fairies, as well as a new creature titled 'Infinity Girl.' Infinity Girls have their arms and legs looped together to make the infinity sign, and they seem to hover over men and make them long for them from a distance." Baseman's "Happy Idiot," the snowman in love with a mermaid who melts so she can live in his body of water, also stems from this period; it was originally drawn on a sheet of hotel stationery in Japan and later fleshed out in his sketchbooks.

"I like art that one can touch," he says. "I like to be able to hold a painting or hold a sketchbook. I love the tangible object. Desire. Longing. Lust. Touch.

"Having said that, I believe computers are a wonderful tool. Even on my TV show, all the backgrounds were originally painted on canvas and then scanned into the computer."

"I never really realized this, but people point out to me that I don't seem to sketch as much as I draw. I don't seem to go over a line over and over again. Once I put down a line, I move on to the next. So instead of creating sketches I am creating drawings."

—Gary Baseman

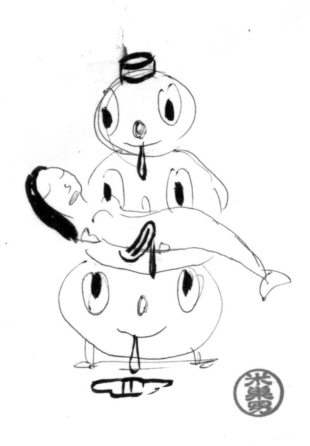

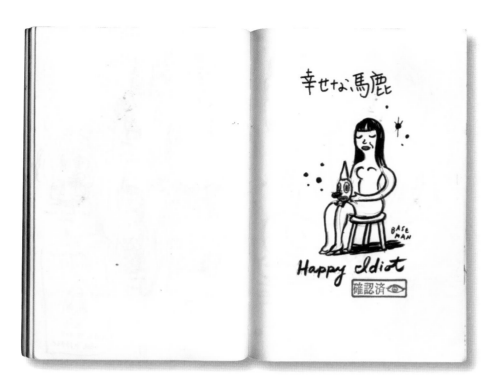

"The Happy Idiot was created when I was traveling to Japan with my friends Mark Ryden and Tim Biskup. We traveled to Tokyo and Kyoto for an exhibition we collaborated on entitled *Hello from Los Angeles*. I was drawing a lot throughout my first Japanese visit. I found myself drawing this snowman over and over again. From there, I found him holding a mermaid, and from there the story was created.

I started to imagine the Snowman, sacrificing himself by melting himself down to allow his love, the Mermaid, to live within his body of water."
—Gary Baseman

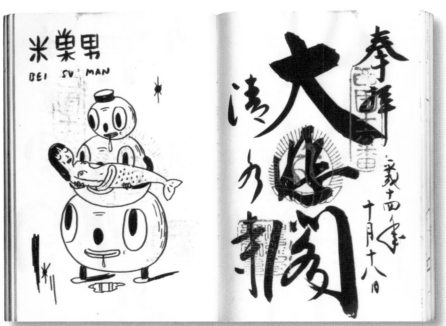

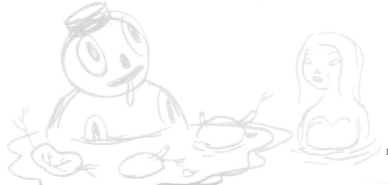

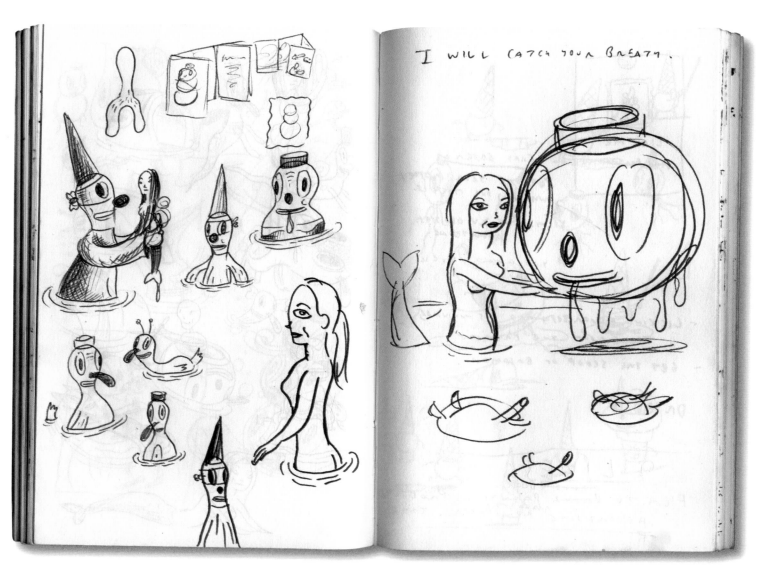

I WILL CATCH YOUR BREATH.

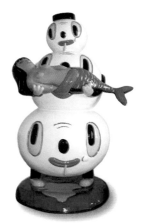

ONE CAN LOOK BUT NOT TOUCH
HI DEE NO ACCEPTED THE RULES.
HE WAS KNOWN AS THE HAPPY IDIOT
HE ACCEPTED HIS DESIRE FOR UNATTAINABLE
BEAUTY, TO LOOK AND NOT TOUCH.
THE INFINITE GIRLS HOVERED OVER-
HEAD, FOR HIM TO ENJOY.
UNTIL ONE DAY HE CAME UPON A
MERMAID. A MERMAID NEAR DEATH.
SHE COULD NOT LIVE OR DAY LONG
THE
SNOWMAN FELT
HELPLESS. HE ALWAYS ADMIRED THE
BEAUTY FROM AFAR, NEVER DARED
TO ENDULGE. (INTERACT).
SHE BEGGED AGAIN. JUST A DRIP.
JUST A DRIP. HOW COULD HE NOT HELP
HIS DAMSEL IN DISTRESS. WITH ONE KISS
HE DROPPED ONE DRIP OF WATER INTO
HER MOUTH. GIVING HER ENOUGH STRENGTH
TO SPEAK.
SHE TASTED SO SWEET, SWEETER THAN
HIS IMAGINATION. THE ONLY ICE
WHOSE HEART BEAT INSIDE HIS ICE
COLD CHEST. HIS CHEST BEGAN
TO BURN. AND BURN. AND FIRE.
HE STARTED TO DROOL
FOR HER.

AS LONG AS DESIRE WAS KEPT WITHIN
THE LAND REMAINED DRY. EASY TO
CONTROL.

MORE AND MORE. HIS DESIRE SO
STRONG. SO INTENSE. HE WAS
WILLING TO MELT HIMSELF
DOWN TO ALLOW HER TO LIVE
WITHIN HIS BODY OF WATER.
THE MORE HE WANTED HER.
THE MORE HE MELTED THE WATER
STARTED TO FLOW. FIRST SMALL
PUDDLES. TO POOLS TO MIGHTY
OCEANS. THE OTHER SIMPLETONS
WHO AT FIRST ACCEPTED THE RULES
SAW HIM MELT AND HIS SELF LESSNESS
AND ALL FOLLOWED SUIT.
THE LAND ONCE DRY, WAS AN OCEAN
OF DESIRE. BUBBLES NO BUBBLES
FILLED THE AIR. PASSION FLOWED
AROUND. SLEEPWALKERS FLOWED THE
OCEAN WITH WATER FROM THEIR
SLEEVES — DREAMS ABOUND.
WET DREAMS FLOWED THROUGH THE
LAND.
THE MERMAIDS DANCED AND
BREATHED LIFE WITH
THEM

Happy Idiot
**Earl McGrath Gallery,
New York**

"I am very ambitious in drawing
in my sketchbook, usually on
a plane. I get a lot done. I also
like taking myself to breakfast
and drawing. And last year,
I started going to one of my
favorite restaurants, named
Dominick's, on Sunday night,
and sitting by the fireplace
and drawing in my books."
—Gary Baseman

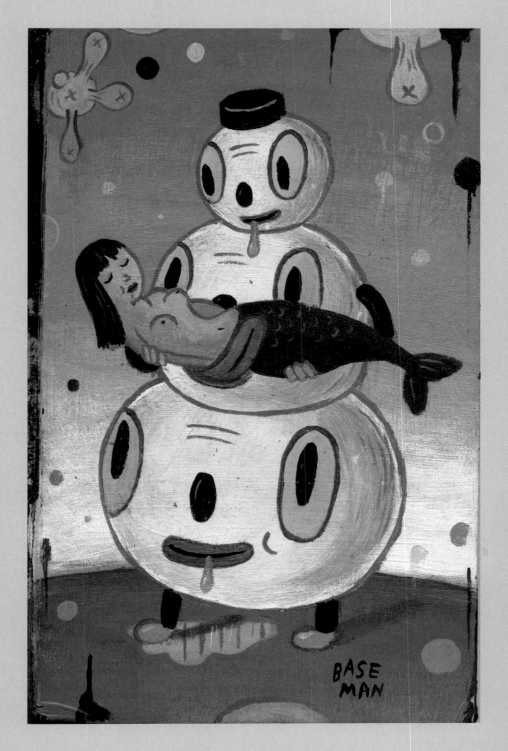

Sam Potts /
Sam Potts, Inc.

New York

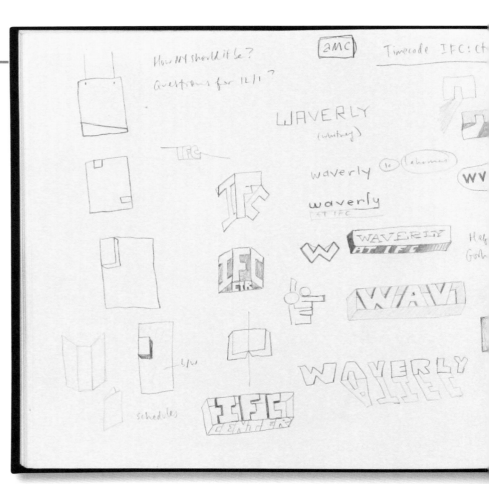

Sam Potts, as the founder and sole employee of Sam Potts, Inc., designs books, websites, identities, and the occasional can of antimatter for clients including the Metropolitan Museum, the IFC Center, and the Brooklyn Superhero Supply Co.

SAM POTTS CAME TO DESIGN relatively late in life. Having graduated with a degree in comparative literature from Columbia University, he found himself editing college textbooks, doing some freelance proofreading, and working as "an orderer of supplies for a variety of offices." His introduction to graphic design came through 'zines, which he published in college and returned to when work was boring. Potts moved from an editorial post at Simon and Schuster to the design department. He later worked for Eric Baker Design Associates and attended Portfolio Center in Atlanta before opening Sam Potts, Inc., in 2002.

Understandably, considering his literary background, Potts's sketchbooks are often filled with more words

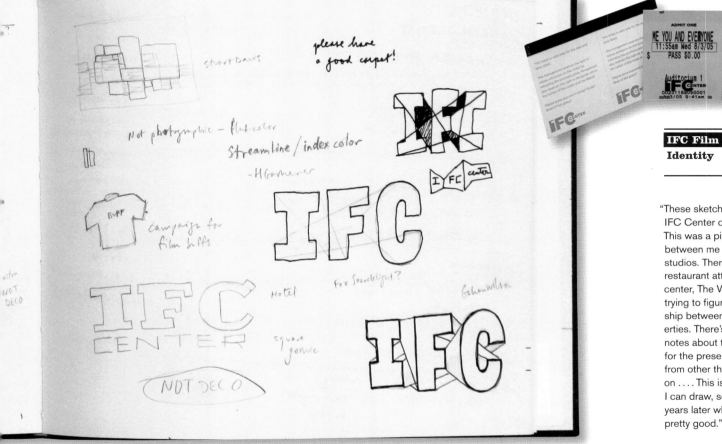

"These sketches are for the IFC Center on Sixth Avenue. This was a pitch competition between me and two other studios. There was also a restaurant attached to the center, The Waverly, and I was trying to figure out the relationship between these two properties. There's also just general notes about things to make for the presentation, research from other theaters, and so on This is about as well as I can draw, so for me to know years later what I meant, that's pretty good."

—Sam Potts

than pictures. "I can't draw my way out a paper bag," he claims. Notes for projects and printing estimates are next to pagelong lists of typefaces. "People are surprised when they see them. They say, 'Don't you know which fonts you like?' Of course I do, but there are so many, and it's easy to forget them. I'm not the kind of designer to use the same five or ten fonts over and over. I like the variety of type; it's a big part of what I enjoy about design. I want to use what's appropriate to the project, not my crutch."

Reflecting his wide range of projects, Potts's books bounce from typeface design to information architecture diagrams. He doesn't, however, paste ephemera into his books, but he does tack inspirational images to the wall behind his desk. "To curate all that stuff into a book is a lot of work, and it makes the book more of an art object. I really use my books to remind me of ideas I've had."

He also rarely purchases the same type of notebook twice. "For a while I was in love with graph paper, and then I went through an unruled phase. It's kind of telling, probably, that I'm undisciplined in the projects I do. But I'm drawn in a lot of different directions, tastewise; I like a lot of old stuff, the nondesigned vernacular stuff and the new, superdigital, designy stuff, too, so it doesn't make a lot of sense to have only one kind of book."

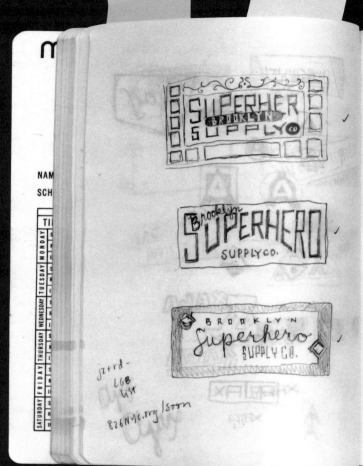

SPI facts

No. of empl. : 1
Estbl. : June 2002
Practices: Web, Book, Identity (logo, signage, collateral)
Want to do more: Music, Restaurant, Packaging
Hours of Operation : 10am - 2am w/ break for chalupa
Platform: Mac + Windows
Custom font design : yes

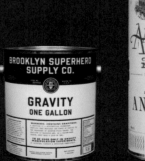

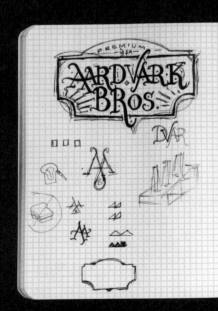

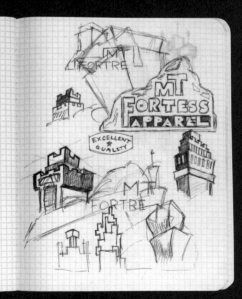

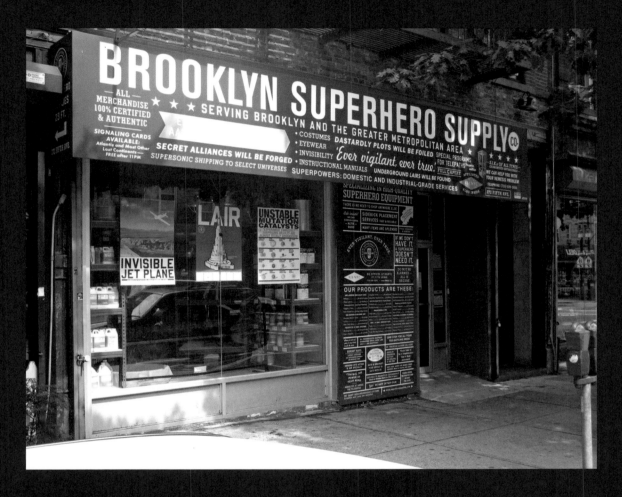

none of that was exactly right
. . . . The store sign was initially going to be tiny little type.

I showed some ideas to Scott Seely, the director of 826NYC, and Dave Eggers, and Dave said, 'These all look like yuppie coffee shops in Park Slope,' and he was totally right. More than the design innovation of McSweeney's, the voice of it is what is so compelling to me, and why it became the journal of the generation, so I suggested something wordy, completely covered in type and he said, 'That sounds about right.'

I was not a comic book reader. I don't know the difference between DC and Marvel, or the various superhero genres—people who know this stuff are pissed off because they think this project is wasted on me. But it's not a comic book store, it's a hardware store, and it's incredibly fruitful territory for jokes, that combination of superheroes and hardware. I thought, 'What would a superhero need? Well, if you fly really fast, you'd need something to hold your hair in place If you turn invisible, you need an invisible wallet.'

All the interior signage and packaging is very low-budget; it's all inkjet printing on sticker paper. We're reprinting them constantly, as there's not a lot of inventory, which allows us to update the products and labels frequently. It's unfortunate not to get paid, but it's not a problem. The recognition has been good but, more importantly, the enjoyment of it has been great."

—Sam Potts

"I knew the guys from the old McSweeney's store. I really lucked out in terms of it being a good fit and good people to work with. They asked if I could do a quick logo for a fundraiser T-shirt, but it had to have a phone booth in it because there's going to be a phone booth in the store, so I did that, and then, what about the storefront? They were talking to Chip Kidd about designing the storefront because he likes comic books, but that fell through. I had been sketching in the meantime for fun. The early idea was a *Popular Mechanics*, retro-futuristic store, a little Victorian, a lot of Chris Ware influence, retro typefaces, yet

Aix
Identity

"When I started out on my own, I had three projects: an identity for a foundation, an identity for a food public relations company, and Restaurant Aix. I had the time and was naïve, so I did like thirty logos, then had twelve rounds of revisions. I wouldn't do it like this today."
—Sam Potts

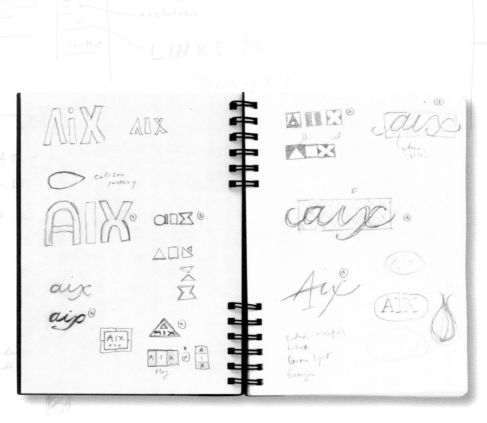

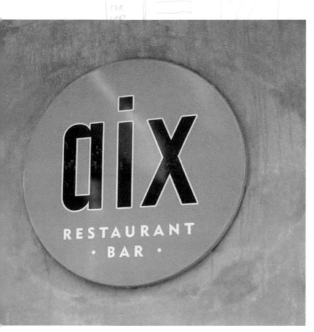

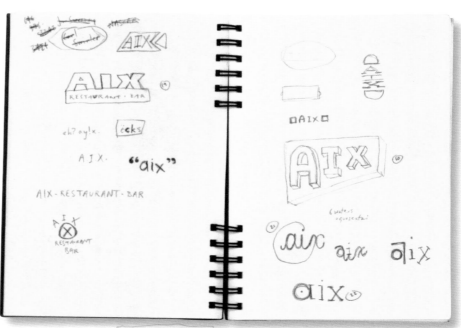

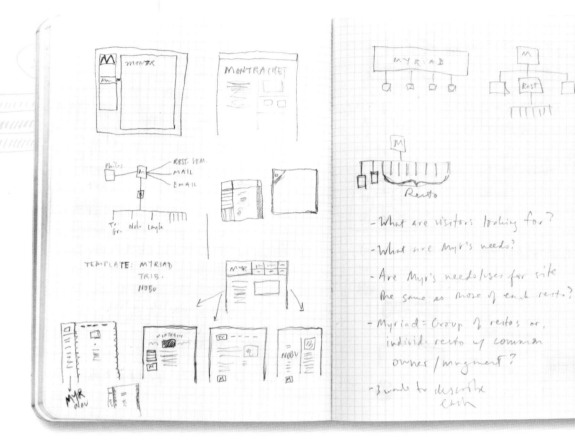

"Information architecture is a very different brain skill than visual design, but I often do both in the same book.

In 2003, the Myriad Restaurant group had twelve restaurants, including Nobu, that had to be represented on one site. This was my first huge project. I was trying to figure out a system where each restaurant could have its own individual look but then have a consistency to link them as a family. I thought of a window-shade slide that you would pull down for navigation. I wanted to do a tab in the corner, but then I realized it looked like the Nabisco logo. It's such a great mark, the triangle in the corner, but Nabisco totally owns it. It's interesting that five years later, the site is still up."

—Sam Potts

Eva Jiricna /
Eva Jiricna Architects, Ltd.

London

Eva Jiricna Architects have an international portfolio of residential, commercial, and retail interiors; furniture, products, and exhibitions; and private and public buildings. The practice is at the forefront of innovation in form and technology, with highly crafted and detailed designs employing classic materials in a thoroughly modern language.

CZECH-BORN FOUNDER Eva Jiricna has been based in London for over thirty years, having settled there shortly before Czechoslovakia's government was overthrown by eastern bloc forces in 1968. Through early commissions for the fashion industry, designing interiors for Esprit and Vidal Sassoon, she quickly became known for her attention to detail.

"I am constantly trying to resolve problems and details," she says. "I need to know what a detail looks like—how the materials come together, how it works in three dimensions. If I draw it for myself, I understand it. If I try to imagine it, it is too whimsical."

Her functional approach and passion for detail come fully into play in her elegant staircases, which have become a Jiricna signature. As Petr Kratochvil

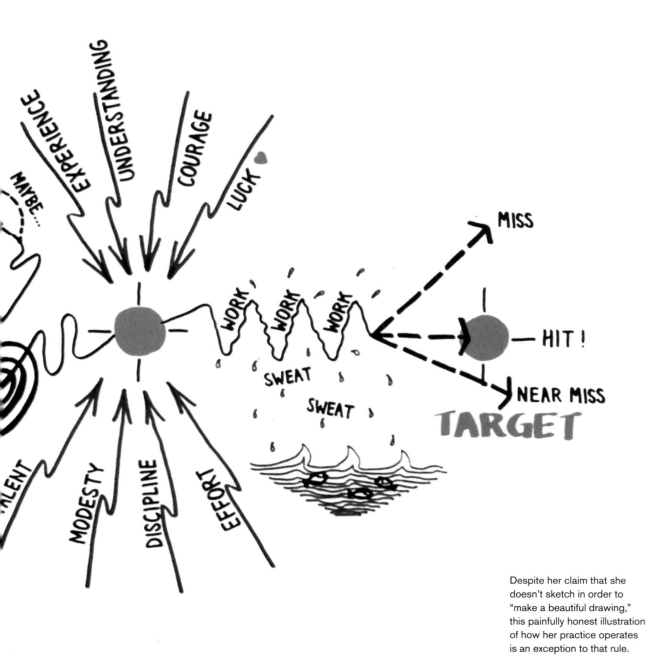

Despite her claim that she doesn't sketch in order to "make a beautiful drawing," this painfully honest illustration of how her practice operates is an exception to that rule.

notes in his essay "The Poetic Minimalism of Eva Jiricna," "A staircase is not just an excuse to create an artifact; it is a means of organizing interior space, of defining its internal organization." He goes on to suggest that Jiricna's design process could be expressed as "design = the logical solution of problems."[6]

"That's the hardest part of the project—to ask questions about everything important to the design and its function. Once a person can find the question, he will also find the answer," Jiricna says.

Jiricna finds her questions and answers through sketching. "I sketch all the time; I am surrounded by endless amounts of A3 and A4 size pads," she says. "Sketching is a tool—an extension of one's brain." Not surprisingly, this analytical approach rarely results in

a beautiful sketch. "I don't sketch to make a beautiful drawing," she says, "but to resolve ideas." Nor does she feel the attraction of designer notebooks, claiming, "I don't carry a sketchbook with me. I find paper everywhere—the back of letters, anything."[7]

Canada Water
Bus Terminal

**Jubilee Line Extension/
London Transport**

"This was one element in the enormous Jubilee Line extension project, in conjunction with a series of bus stations to connect the urban areas to the Underground. Canada Water is situated close to a high-rise housing development, and it was necessary to satisfy the requirements of the residential environment by providing the bus station with a roof that was relatively attractive to look down upon as well as one that gave protection from bus traffic pollution and created an acoustic barrier. There was an inherent problem in that there were only five points of support, since the bus station was to be erected over a tube station while it was still under construction. The two large wings forming the roof are carried by a central space-frame, acting as a main construction beam from which the wings are cantilevered.

The underside of the roof is provided with acoustic panels to absorb noise; simultaneously they act as light reflectors at night when the uplighters come into use as the main source of illumination, helping to keep the internal space cheerful and airy."
—Eva Jiricna

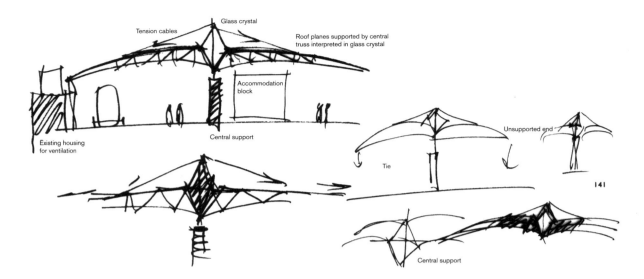

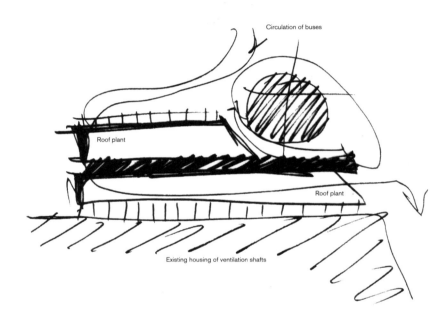

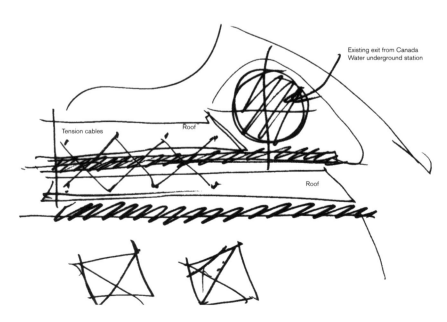

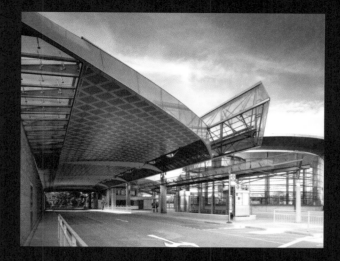

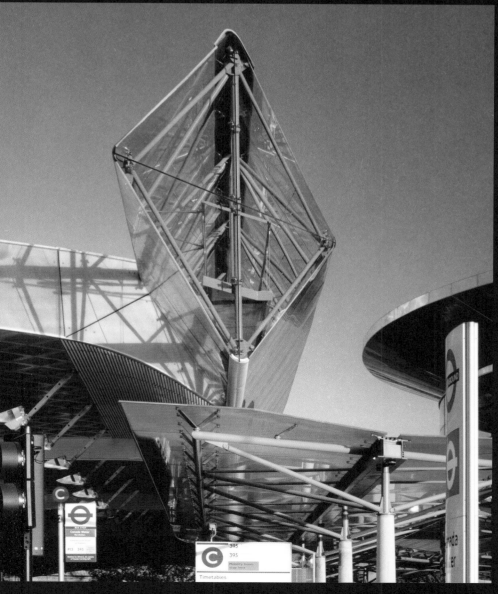

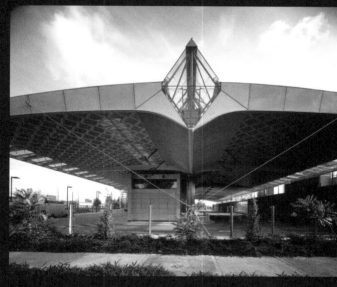

The Orangery Greenhouse

Prague Castle Management

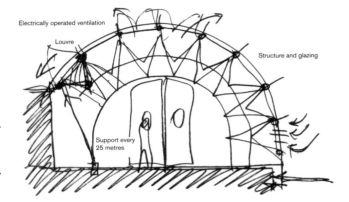

Electrically operated ventilation

Louvre

Structure and glazing

Support every 25 metres

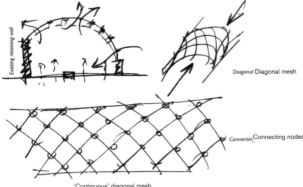

Existing retaining wall

Diagonal Diagonal mesh

Connectin Connecting nodes

'Continuous' diagonal mesh

"Limited access to the site of this historic fifteenth-century greenhouse [Prague Castle Orangery, Prague], plus the difficulties of providing an adequate foundation, led to the design of a diagonal mesh stretching between the cross-frames. The glass is suspended from the new structure in large laminated panels, and watering of the plants is accomplished by a computer-controlled system and automatically operated sunshades."

—Eva Jiricna

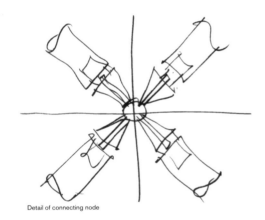

Detail of connecting node

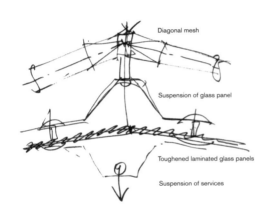

Diagonal mesh

Suspension of glass panel

Toughened laminated glass panels

Suspension of services

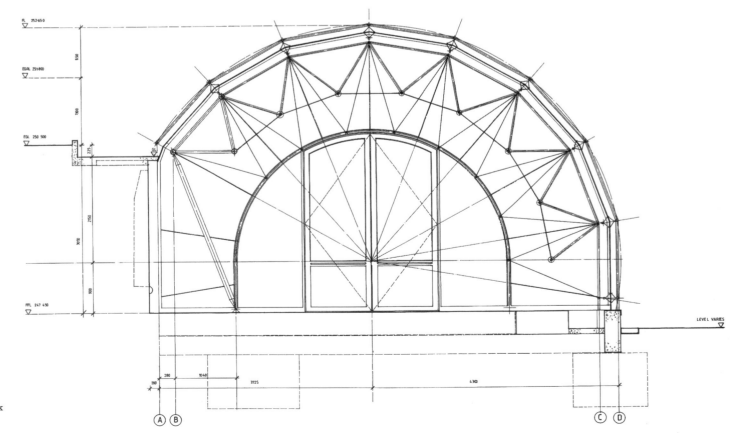

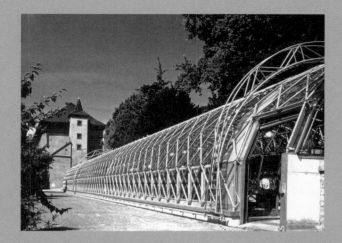

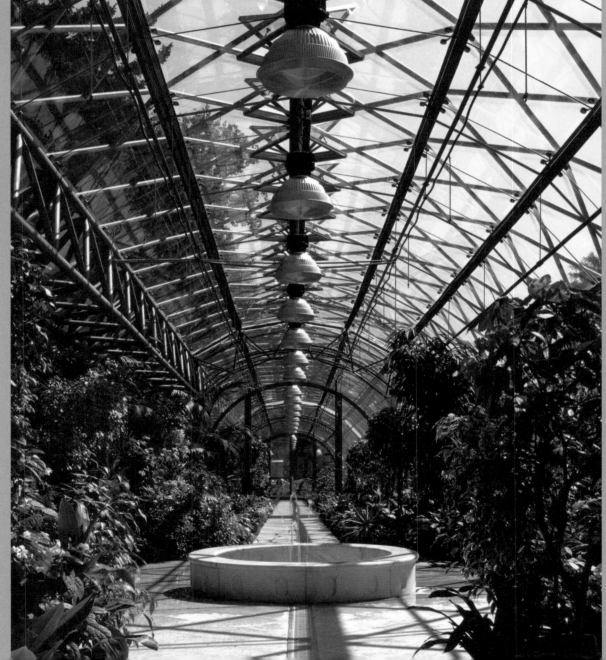

Dave Eggers/ McSweeney's

San Francisco

In April 2005, in New Orleans, author Dave Eggers was interviewed onstage by Anne Gisleson at the Tennessee Williams Festival. Eggers talked about his firsthand experiences with the Patriot Act and the perils of one's private sketchbook falling into the government's hands. The following is a slightly edited transcript of that interview.

[IN 2004] I HAD BEEN GRANTED a press pass to the Republican National Convention in New York City. I was sitting there, and I was trying to take notes and I couldn't because I realized I didn't have my notebook with me. And at that moment I realized that I had left it on a plane. It was just a plain black notebook. I called the airline from the convention and I said, "Have you found a notebook? It was on this flight at such-and-such a time." And the woman at the airline said, "Oh, actually a notebook was turned in to the lost and found. We have it right here." I described it, and she said "Yeah, that's the one." And I asked her if she could send it to me and she said, "Yeah, sure we can send it to you." And I gave her my address, and she said she would send it to me. It was altogether the most satisfying customer service experience I've ever had in my life. I mean, you never think you're going to find something you leave on a plane. So that was it, and then I went about my business. I thought she was going to send it back to me in San Francisco.

Then I got a call two hours later, no more than two hours. There was a message on my machine saying "Hi, Dave. This is Mike McGillicutty"—that's not his real name—"from the State Department and I'm in

"IT WAS WORTH IT!"

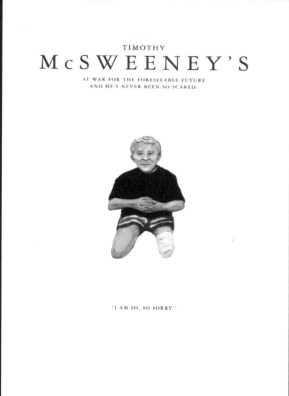

TIMOTHY
McSWEENEY'S
AT WAR FOR THE FORESEEABLE FUTURE
AND HE'S NEVER BEEN SO SCARED.

"I AM SO, SO SORRY."

**McSweeney's #14
Book Cover**

McSweeney's Books

possession of your notebook. Why don't you give us a call back to talk about it?"

And I have to admit, I was pretty excited. This was the first call I'd ever gotten from the State Department, and I just thought, "Okay, this is going to be great. No matter what happens, it'll be an adventure." So I called him back, and he said, "Yeah, you know, there was some concern about the contents of your notebook. The lost-and-found woman and the Port Authority police" Apparently my notebook, and the concern about it, had gone up about four agencies in those two hours and eventually got to the State Department. I was pretty amazed, and even more excited about what was happening. I mean, this was getting good.

So I said "Okay, so what happens? I go to jail, or what happens?"

He said, "No. I just want to talk to you about it."

And I said, "Okay, are we going to talk now?"

And he said, "No, no. Let's see. I know you're flying out tomorrow on JetBlue at 8:10 a.m., so why don't I just meet you at the gate?"

And of course that was kind of alarming, that he knew when I was flying back home. But anyway, I said "Okay, I guess I'll meet you there."

I still didn't want to tip him off that, you know, I wasn't a dangerous guy. So I just let it go, and in the meantime, all that night, I was thinking about the meeting the next day. I mean, first of all, what do you wear to something like that? I was going to meet him at the gate and I didn't really have anything nice or dressy or anything. I thought I could at least bring a flower or something, like a rose maybe for him. I didn't know the protocol.

I had asked how I would know him, and he said he'd be holding my notebook. So the next day I came into the JetBlue gate and he was there with the notebook, but otherwise he was dressed like he'd been playing golf. He had khakis on, and a polo shirt, and he looked about twelve years old. And this was the guy from the State Department!

So I walked up to him, and we stood at one of those high café-type tables, and immediately I was sort of disappointed, because it became apparent right away that somewhere between the phone call and that morning he had looked me up and realized that I wasn't a dangerous guy—which was too bad. I was really hoping there was some list out there of dangerous writers and I was one of them. But no, immediately

"I don't have a sketching routine per se, but when we're coming up with a new McSweeney's cover, I usually start with a sketch on paper.

With the cover of McSweeney's no. 14, I had just read a story about soldiers who had been injured in the war, amputees in particular. And I was so angry about the poor planning of the war, and the lack of foresight, and the lack of compassion, and the stupidity that I thought drawing Bush as an amputee might be a way to vent. So I sketched it out. Some people were pleased and others obviously upset by it."

—Dave Eggers

he said there was no big problem, he knew who I was, and I guess more importantly, who I wasn't.

So he asked me some really basic questions. The first question he asked me, honest to God, was my Social Security number. Now, this threw me a bit. He knew my flight number and time, but he couldn't find my Social Security number? If the State Department doesn't have access to your Social Security number, there's some kind of disconnect with the information flow, right?

I gave him the number, and then I had to ask him what it was about the notebook that had triggered all the concern. And so together we started flipping through it, and what we saw was actually pretty alarming. I had just been at this Sudan conference, so words like *Sudan, war, SPLA, rebels, Osama bin Laden*—these were all in the first five pages. Bin Laden had lived in the Sudan for five or six years and had been harbored by the government and paid for a lot of their terror. Then on the next page I'd written *Colin Powell, Condaleeza Rice, State Department*, things like that, because Rice and Powell actually had a great interest in Sudan; they'd helped broker the peace agreement there. Later in the notebook I'd written some details about the

Republican National Convention, dates and times and locations of various meetings I planned to attend.

That was all fairly interesting, I guess, to any sort of authority tasked with protecting everyone at the RNC. And then we kept flipping through the notebook, and we came across something even stranger. See, when I'm bored at a meeting, I'll sometimes draw in my notebook. I use a china marker, which has a rough edge to it; it has the effect of looking like it was done in crayon. And when I was sketching in this particular notebook, the drawings happened to be of huge furry creatures with big teeth. And alternating between the drawings of creatures with teeth were these big drawings of flames. Sometimes I draw sort of cartoon-versions of flames. It's something I needed to do for an illustration assignment years ago, and I just kept in the habit of drawing them sometimes. They're very cute flames, I have to say, but in the context of this notebook, they had a different implication. Any reader of this notebook would be concerned, for sure, when you put it all together: bin Laden, Sudan, Powell, Rice, State Department, Republican National Convention, New York City, huge furry monsters, flames, flames, flames. It definitely would raise eyebrows on anyone.

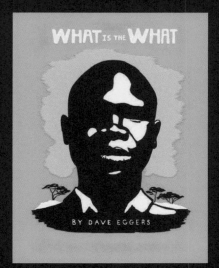

What Is the What
Book Cover

McSweeney's Books

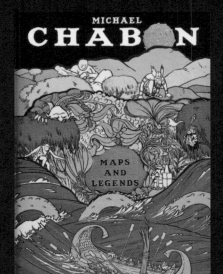

Maps and Legends
Book Cover

McSweeney's Books

Sterling Brands

New York

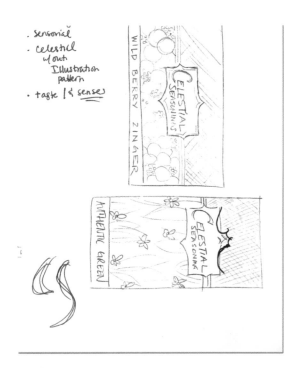

Led by Debbie Millman, Sterling's design group combines intelligence, energy, and passion to develop distinctive and inspirational work.

In flipping through their sketches, Millman, director of research and development Jen Simon, and designer Joe Rosa are reminded of each project's challenges. "Nobody ever comes to us and says, 'You have an unlimited amount of time and an unlimited budget—do whatever you want,'" says Millman. Simon adds, "They'll often say, 'We'll brief you next Tuesday, but we need the design for the Monday before we brief you.'"

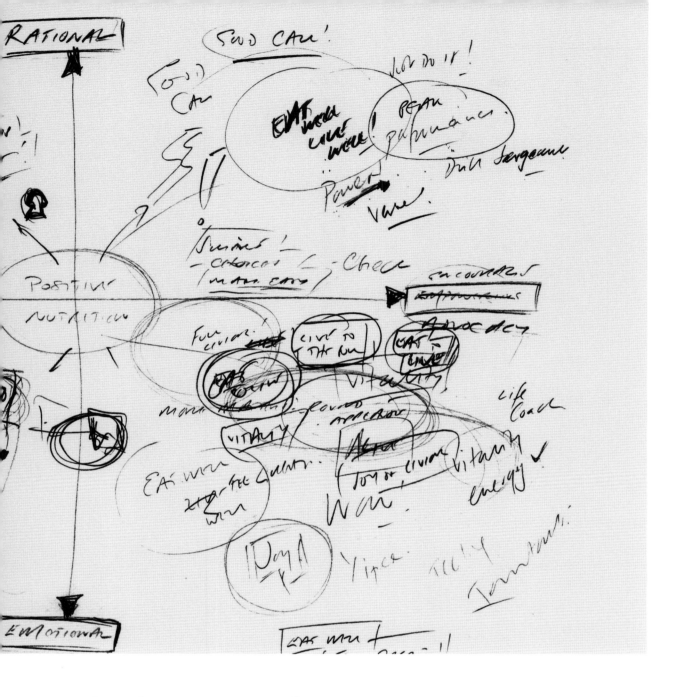

Working on five to ten projects at once, Millman's group consists of five teams of designers (plus strategy, marketing, accounting, and production teams). These all produce reams of notes, sketches, and explorations on whatever paper is handy—one sketch done on a piece of Landor letterhead raises a laugh and some speculation as to how it ended up there. Rosa's creative approach is representative of the studio at large: "When I start sketching, I usually go through books and magazines and clip or photocopy any inspiration I can find, and then spread it out and take it from there."

Though the studio is certainly not messy, its controlled chaos has a palpable sense of creative energy; there seems to be a different project on each monitor, and books and papers are everywhere. "Wait until you see my office," Millman laughs.

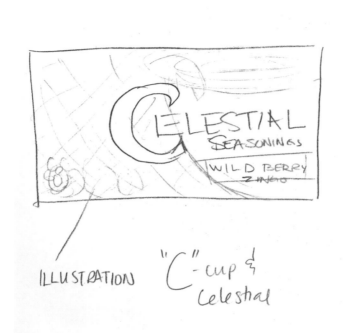

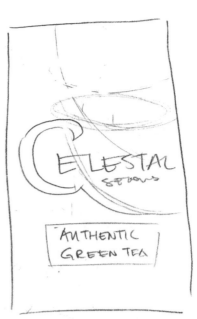

ILLUSTRATION "C"-cup &
Celestial

Celestial Seasonings
Packaging

"We did tons of drawings for Celestial Seasonings. They wanted something revolutionary, and then three-quarters of the way through, we found out we had to use the original illustrations—they have almost a hundred flavors, so there just wasn't the budget. What we found, though, was that most of the illustrations had been incredibly cropped into; they're actually amazing paintings once you show them in their entirety and give them some room to breathe."

—Debbie Millman

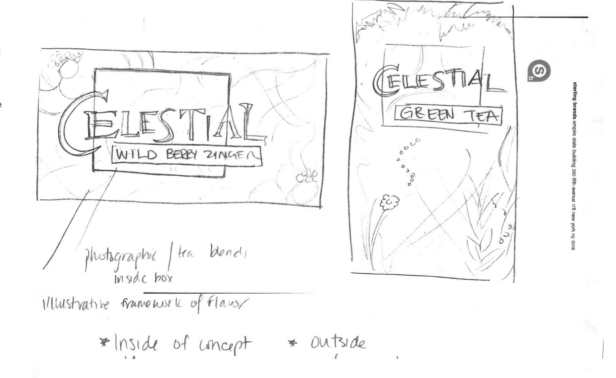

photographic / tea blends
inside box

Illustrative framework of flavor

* Inside of concept * outside

sterling brands empire state building 350 fifth avenue 17th new york, ny 10118

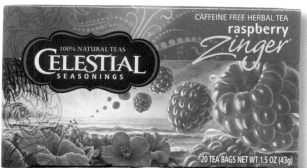

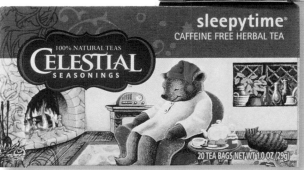

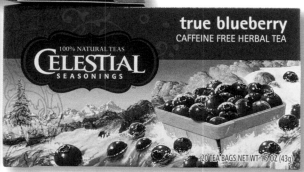

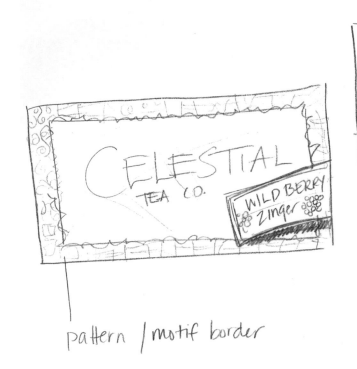

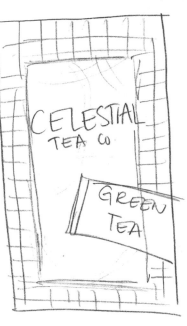

pattern / motif border

Rian Hughes/
Device

London

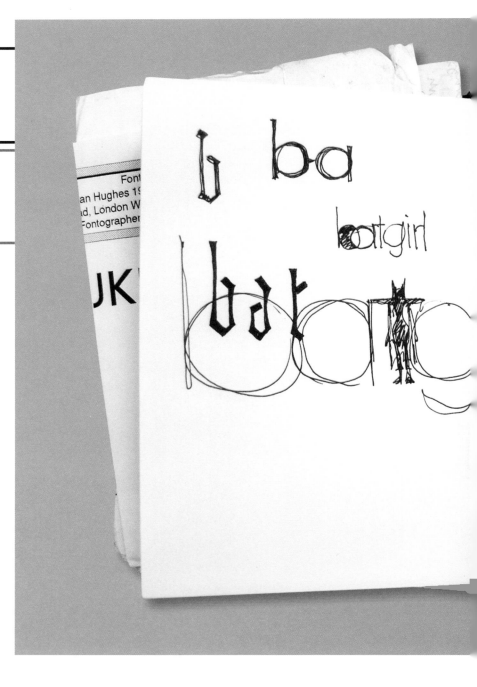

Batgirl
Logo

DC Comics

Rian Hughes has a restless creativity that refuses to be limited to a single discipline. He has created comic books for DC Comics, dozens of typefaces for his type foundry, Device, and illustrations for clients including Virgin Atlantic, Swatch, and MTV, rendered in a pop-modernist style that has spawned a legion of imitators.

DESIGNER/ILLUSTRATOR/TYPOGRAPHER RIAN HUGHES is among the Moleskine notebook's many supporters, though he's quick to point out that getting the idea down is more important than what you do it with. "If my Moleskine isn't on hand, sticky notes and the proverbial backs of envelopes also serve. My sketchbooks are very much idea diaries and include lots of written material with diagrams, doodles, titles for projects, story ideas, and places and subjects I need to research. These are mostly written in a personal form of shorthand, which I sometimes can't decipher myself. On rereading, some of it sounds pretty abstract, while other snippets are simple and direct, almost like T-shirt slogans: 'Label Whores,' 'Global Village Idiots,' 'How to Kill an Idea,' 'The Gaza Strip Gentleman's Club,' etc."

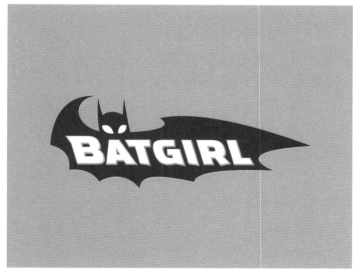

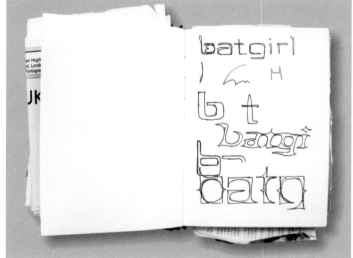

These short phrases hint at Hughes's wry sense of humor, which finds its way into his illustration work and his typeface design. Both express a delicately maintained balance between nostalgia and futurism; both are rendered with absolute precision yet retain a flowing, organic dynamism and a roving imagination. "I get many of my ideas as I'm dropping off to sleep. The brain is freewheeling then, and can come up some interesting and novel connections."

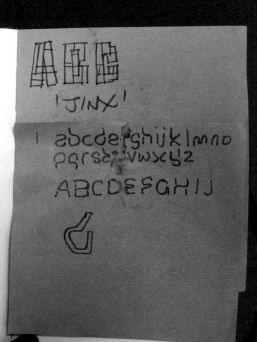

'JINX'

abcdefghijklmno
pqrstuvwxyz

ABCDEFGHIJ

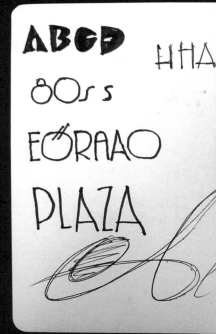

ABCD HHA

80rs

EORAAO

PLAZA

FGHIJKLM
MNOPQRST

Ala Piped music

Blackguard

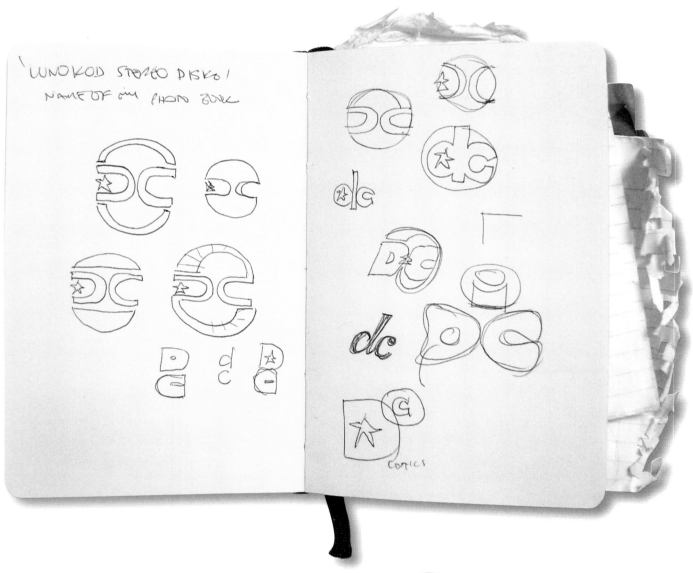

"There is a spontaneity that can be lost between sketch and final art, but as my sketches are so simple, I don't usually finish a sketch to a high level before embarking on the final piece."
—Rian Hughes

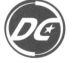

> **"Computers have allowed students to go straight to step two: execution. But too many of them have no idea of step one: thinking."**

JAMES VICTORE is a self-taught, independent graphic designer whose work includes publishing, posters, and advertising for numerous clients, including Moët & Chandon and the *New York Times*. His posters are in the permanent collections of the Palais du Louvre, Paris, and the Library of Congress, Washington, D.C. He teaches graphic design at the School of Visual Arts in New York City and is a member of the Alliance Graphique Internationale (AGI).

Q+A/ James Victore / James Victore, Inc.
Brooklyn, New York

Q. How do you sketch? Is it mainly stream-of-consciousness doodling, or is it more purposeful, problem-solving sketching?

A. I sketch constantly. My sketches are not doodles, nor are they technical drawings. They are a shorthand, an external thinking process. I rarely sketch in the studio. What is most useful is to leave the studio with my sketchbook and a few pens and go ruminate on a project. Bars and restaurants are very useful. Airplanes work very well, too.

Sketching, for me, is a huge part of my process. Usually the sketch has all the bits and elements of the final work—even in the right proportions. All I have to do is follow the sketch. Sometimes we just break down and use the sketch as final.

Q. What do you think the importance of sketching is in an art education? Do you encourage your students to do more of it?

A. No, I never encourage my students to sketch. They need to find their own way, sketching included. I cannot impose my way of thinking or technique on anyone.

Q. Have you noticed a shift in the way your students approach projects, how they nurture ideas and bring them to fruition, as the field has become computerized? I'm thinking of how accelerated everyone's lives have become, coupled with the overwhelming amount of visual information we all have to process. What can sketches do that working directly onto the computer can't accomplish?

A. Good question. Computers have allowed students to go straight to step two: execution. But too many of them have no idea of step one: thinking. Sketching and drawing are important tools for a designer. It is a way of training your mind. It is like learning to play a sport, but not having any hand-eye coordination you will go through the motions of something that looks like a sport, or be very technical about it, but not actually be very good at it. I see soooo much work out there that is done by designers who can't draw. You can tell. And what's worse, real human beings can tell. They sense it without knowing. They feel it. This kind of work robs us of our daily beauty. Designers make art for the street, whether they own up to that responsibility or not. And drawing is the basis of it all. Always has been.

Q. Do you show clients sketches before proceeding to a finished piece? Or do you see your sketches as private property?

A. My sketchbooks are ugly. They are how I think, and they are very private. I like to show clients something rough—but not that rough. I think my clients would be shocked at viewing my sketchbooks.

Q Do you ever complete a project and feel the sketch was more successful than the ultimate solution?

A Always.

Q Why do you think this is?

A The reason is: I am not thinking when I sketch. I try not to think like a designer to begin with, but in my sketchbook my thoughts are very free, and trying to reign in that freedom and keep it fresh is difficult.

Q This passage from Ayn Rand's *The Fountainhead* resonated with me:
He found himself suddenly in his glass-enclosed office, looking down at a blank sheet of paper—alone. Something rolled in his throat down to his stomach, cold and empty
He leaned against the table, closing his eyes. It had never been quite real to him before that this was the thing actually expected of him— to fill a sheet of paper, to create something on a sheet of paper.[8]

Q Hopefully not to the degree in the above quote, but do you ever feel nervous approaching a blank piece of paper?

A Always. One of my mentors told me, "The paper is as free as the canvas." This was not a freeing idea. It rather scared the crap out of me. All beginnings are hard.

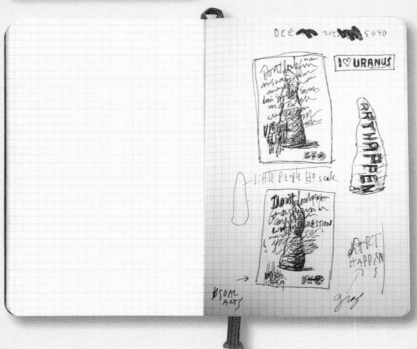

The sketchbooks
of designer
Aimee Sealfon

Liska + Associates Inc Communication Design

Refined

"A work of art goes through
many phases of development,
but in each phase it is always
a work of art."

Hans Hofmann
*Theories of Modern Art: A Source Book
by Artists and Critics*

Stefan G. Bucher /
344 Design

Los Angeles

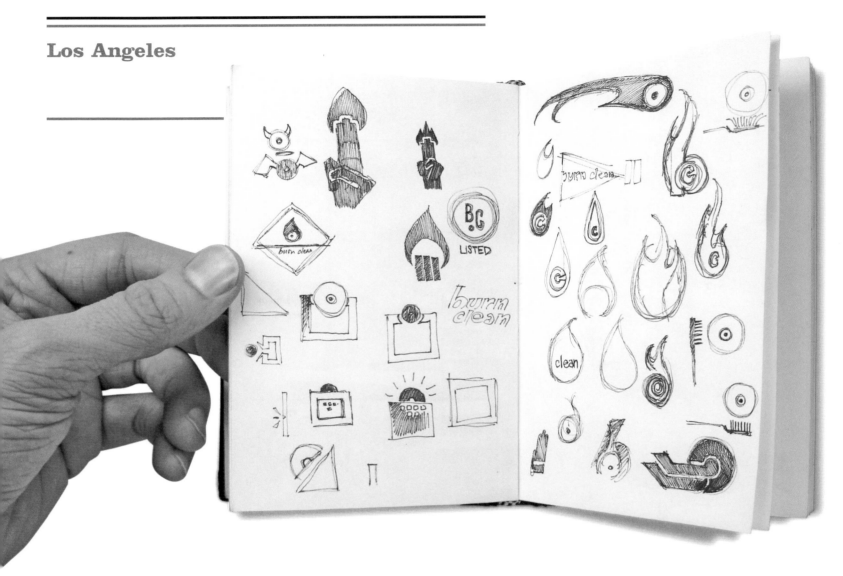

Graphic designer and illustrator Stefan G. Bucher is the man behind design studio 344 Design and the wildly popular online animation series Daily Monster, recently collected in the book *100 Days of Monsters*. When not bringing monsters to terrifying, inky life, he produces award-winning work for clients as diverse as the L.A. Louver gallery, NYTimes.com, and film director Tarsem.

NO ONE WHO has visited dailymonster.com and watched one of the 200 videos of Bucher creating a monster from a random ink blot will be surprised to learn he is a prolific sketcher. The man clearly knows his way around a pen. Still, he admits that while he used to do a page or two a day in his sketchbooks, he isn't drawing as much lately as he'd like. "A lot of that activity has gone into making the monsters," he says. "I do put a lot of doodles on the backs of bills, postcards, and envelopes on my desk, and I try to save those because it'll look so damn authentic and impressive once the Smithsonian gets my estate. But doodling random sketches here and there isn't the same as committing to a sketchbook. I started my current volume on October 1, 2005, and I'm not even halfway through. It's embarrassing!"

"Sketching is more free and immediate than working on the computer. It's very quick and easy to run through basic ideas on paper. Also, anything that involves complex curves has to start on paper. Curves really benefit hugely from the natural motion of the hand.

The Roxio logo started as a tag on ads I was designing for Modernista! in Boston. Roxio wanted to brand them with the slogan 'Burn clean' to make clear their products (Toast and EZ CD Creator) are intended only for burning content you own. The ads did well, and when Roxio approached Modernista! about designing a new company logo, they called on me once more. I told them they already have the perfect logo, and the M! team made it happen."

—Stefan Bucher

"I started drawing a series of hybrid animals about ten years ago. They'll be a book someday, you just wait. In the meantime, Honda has licensed the warthen, the moosetrich, and the pengvark to advertise their line of hybrid vehicles."

—Stefan Bucher

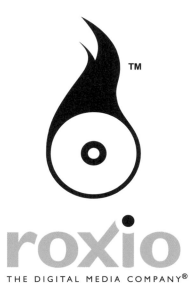

roxio

THE DIGITAL MEDIA COMPANY®

Even for someone whose work makes frequent use of hand-drawn elements, it can be hard to take the time sketching's slower pace demands. "There are always excuses for not sketching enough. Sketching is like going to the hand-eye gym: It rewards consistent, disciplined effort; it's easy to lapse; and it's yet another way to feel guilty about doing too little of what's good for you.

"Sketching is perfect for logos, because in the end anybody anywhere should be able to doodle your logo in seconds. For layouts, sketching hasn't been that useful to me; it's too easy to cheat dimensions and proportions in a thumbnail. I prefer working with the actual ingredients as soon as possible. The computer allows me to run through more configurations than a sketchbook because it's so easy to manipulate colors and scale."

In the end, combining both tools works best for Bucher. "I think if it's a good idea, and you develop it with care and discipline, it'll become a good piece whether you work on it with a pencil or a computer. I don't think tools have anything to do with conceptual depth."

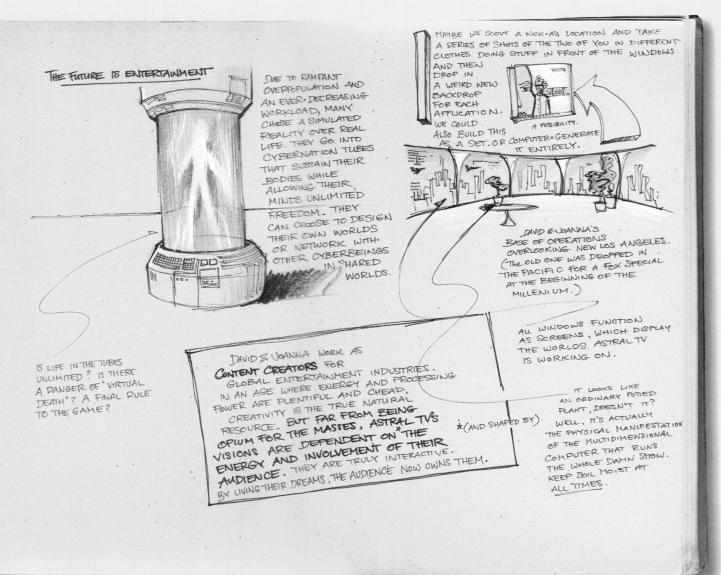

THE FUTURE IS ENTERTAINMENT

DUE TO RAMPANT OVERPOPULATION AND AN EVER-DECREASING WORKLOAD, MANY CHOSE A SIMULATED REALITY OVER REAL LIFE. THEY GO INTO CYBERNATION TUBES THAT SUSTAIN THEIR BODIES WHILE ALLOWING THEIR MINDS UNLIMITED FREEDOM. THEY CAN CHOOSE TO DESIGN THEIR OWN WORLDS OR NETWORK WITH OTHER CYBERBEINGS IN SHARED WORLDS.

MAYBE WE SCOUT A KICK-ASS LOCATION AND TAKE A SERIES OF SHOTS OF THE TWO OF YOU IN DIFFERENT CLOTHES DOING STUFF IN FRONT OF THE WINDOWS AND THEN DROP IN A WEIRD NEW BACKDROP FOR EACH APPLICATION. WE COULD ALSO BUILD THIS AS A SET. OR COMPUTER-GENERATE IT ENTIRELY.

A POSSIBILITY.

DAVID & JOANNA'S BASE OF OPERATIONS OVERLOOKING NEW LOS ANGELES. (THE OLD ONE WAS DROPPED IN THE PACIFIC FOR A FOX SPECIAL AT THE BEGINNING OF THE MILLENIUM.)

IS LIFE IN THE TUBES UNLIMITED? IS THERE A DANGER OF "VIRTUAL DEATH"? A FINAL RULE TO THE GAME?

ALL WINDOWS FUNCTION AS SCREENS, WHICH DISPLAY THE WORLDS ASTRAL TV IS WORKING ON.

DAVID & JOANNA WORK AS **CONTENT CREATORS** FOR GLOBAL ENTERTAINMENT INDUSTRIES. IN AN AGE WHERE ENERGY AND PROCESSING POWER ARE PLENTIFUL AND CHEAP, CREATIVITY IS THE TRUE NATURAL RESOURCE. BUT FAR FROM BEING OPIUM FOR THE MASSES, ASTRAL TV'S VISIONS ARE DEPENDENT ON THE ENERGY AND INVOLVEMENT OF THEIR AUDIENCE. THEY ARE TRULY INTERACTIVE. BY LIVING THEIR DREAMS, THE AUDIENCE NOW OWNS THEM.

*(AND SHAPED BY)

IT LOOKS LIKE AN ORDINARY POTTED PLANT, DOESN'T IT? WELL, IT'S ACTUALLY THE PHYSICAL MANIFESTATION OF THE MULTIDIMENSIONAL COMPUTER THAT RUNS THE WHOLE DAMN SHOW. KEEP SOIL MOIST AT ALL TIMES.

"David and Joanna from the Solar Twins had a strong vision that they wanted their music and stage show to transport their audience into a parallel reality. We conceived of a minimalist penthouse that functions as a giant teleportation device—the Tardis meets Edna Mode's house. Throughout the project, the band and I had a great mind meld, which makes this my favorite music project so far."

—Stefan Bucher

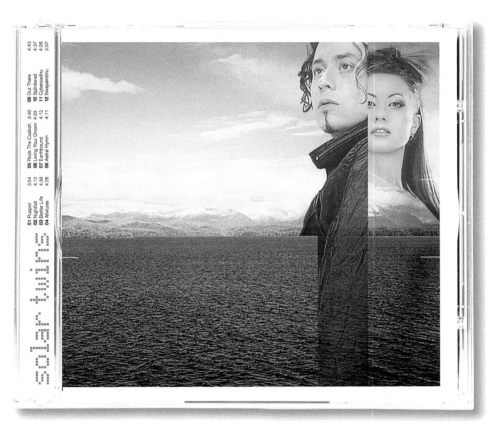

PETER SHELTON

JOEL SHAPIRO

MICHAEL C. McMILLEN

JASON MARTIN

DAVID HOCKNEY

FREDERICK HAMMERSLEY

DALE CHIHULY

OPEN
INTELLIGENCE
AGENCY
RUSSELL DAVIES
LONDON

+44 (0)7976 974 340
russell@openintelligenceagency.com

OPEN
INTELLIGENCE
AGENCY
DAVID NOTTOLI
NEW YORK

david@openintelligenceagency.com
+1 917 207 4387

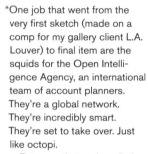

"One job that went from the very first sketch (made on a comp for my gallery client L.A. Louver) to final item are the squids for the Open Intelligence Agency, an international team of account planners. They're a global network. They're incredibly smart. They're set to take over. Just like octopi.

Between that and conflating in my memory the posters on page 45 of my favorite design book, *Genius Moves*, everything was set for a squiddy ID. I made a dozen squid icons, and—since these are very cool clients—we used them all."
—Stefan Bucher

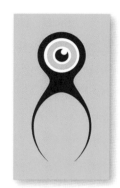

OPEN
INTELLIGENCE
AGENCY
JEFFRE JACKSON
AMSTERDAM

+31 (0)6 4390 8261
JEFFRE@OPENINTELLIGENCEAGENCY.COM

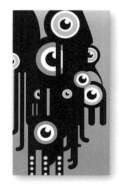

OPEN
INTELLIGENCE
AGENCY
EMILY REED
SYDNEY

+61 4 1241 9644
emily@openintelligenceagency.com

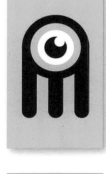

OPEN
INTELLIGENCE
AGENCY
DAVID NOTTOLI
NEW YORK

david@openintelligenceagency.com
1 917 207 4387

OPEN
INTELLIGENCE
AGENCY
EMILY REED
SYDNEY

emily@openintelligenceagency.com
+61 4 1241 9644

OPEN
INTELLIGENCE
AGENCY
JEFFRE JACKSON
AMSTERDAM

jeffre@openintelligenceagency.com
+31 (0)6 4390 8261

OPEN
INTELLIGENCE
AGENCY
DAVID NOTTOLI
NEW YORK

1 917 207 4387
david@openintelligenceagency.com

Chris Bigg

Isle of Wight, England

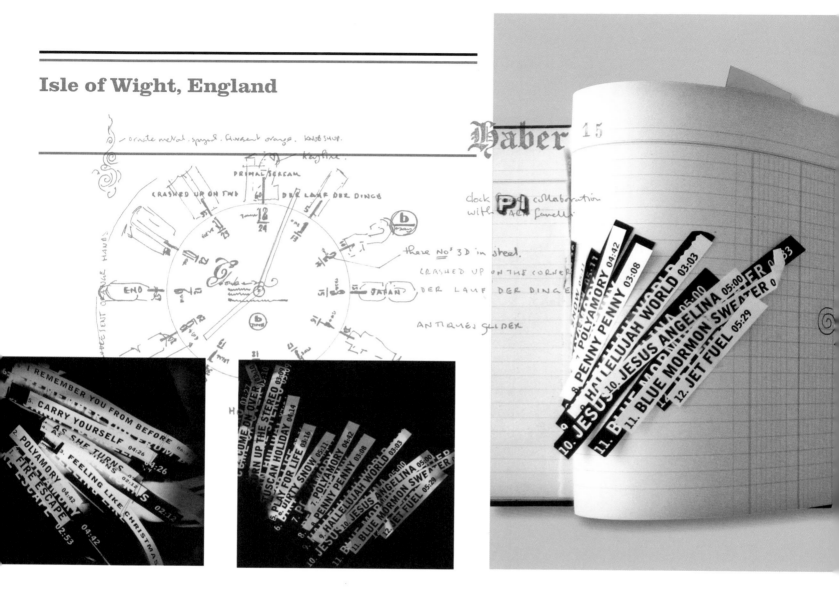

In 1987, Chris Bigg joined Vaughan Oliver at 23 Envelope (later v23), where their work for 4AD Records, among others, has had a dramatic impact on graphic design. Bigg is perhaps best known for his expressive typography and calligraphy.

VAUGHAN OLIVER'S WORK for the seminal British record label 4AD had already garnered critical acclaim and the adulation of music fans by the time Bigg arrived. Chris was fresh from stints at Platform Design and music packaging specialist Stylorouge, and the influence of his sprawling calligraphy and intricate typographic detailing was felt immediately. Oliver has said of Bigg, "He produces this beautiful tangle, and I say, 'Put that next to it. Take that out of it.' I give it some space. He produces a lot of nervous energy. Conceptually, he'll agree with something, then add some details that complement it and expand it."[9]

This tangle of ideas is nowhere more apparent than in Bigg's sketchbooks. "I don't do it as much as I used

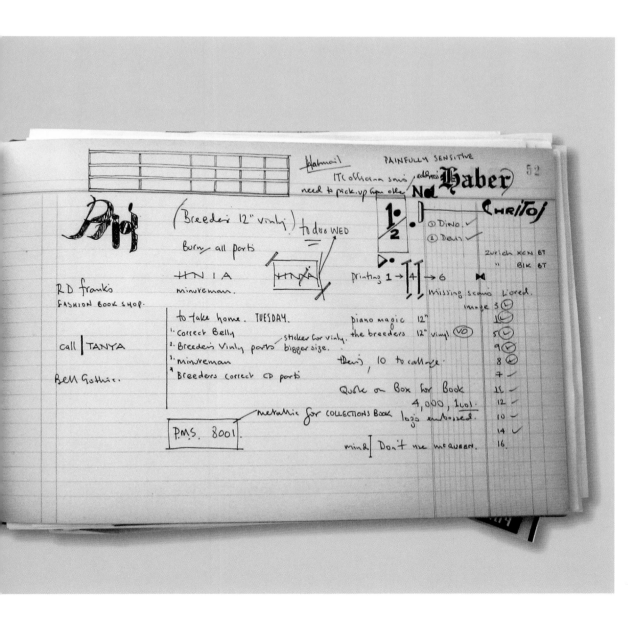

"I found four or five of these old Spanish accounting ledgers in a flea market in Barcelona; it took me a few years to fill them up."
—Chris Bigg

Jacob Golden
Music Packaging

Rough Trade Records

"I ended up putting this sketchbook under the PMT camera, and it became the back cover for a record by Jacob Golden. I think it's one of the nicest backs I've ever done, but it kind of got lost on a record that no one bought. Jacob came in—he was the strangest fellow, very sweet, looked a bit like the guy from *Midnight Cowboy*—and he said, 'I've got this amazing idea for the back; you know the mixing desk, where they have the bits of tape all over it?' and I thought, 'Oh, bloody hell— we've seen that one before, haven't we, Jacob?' So I said I'd do an interpretation of that, and cut up all these photocopies and slapped it down, and he loved it. It's quite interesting how someone can have a vision, and you can turn it around with a bit of artistic license. That's what makes the job enjoyable: when you've got conviction in an idea and the client lets you go with it, and it works. Few and far between, those moments."
—Chris Bigg

to," he admits. "I used to sketch every day, when I was still discovering my visual identity. I could doodle with letters and typefaces for hours—I'd take an F and see how far it could go before it stopped being an F. I wanted to make the most beautiful F I had ever seen. When I sketch, there's always a sense of automatic drawing, making shapes with letters, often not for any project in particular but just for the desire to surprise myself."

Bigg also appreciates his sketchbooks as historical documents. "I paste in my collection of found lettering—wine labels, tickets, and other typographic detritus," he says. "Anything I can pull apart at a later date and make my own. I've always loved the way

an incidental tear on the side of a cardboard box can inspire you, how a juxtaposition of elements you'd never have dreamed of putting together can become the basis of an entire campaign. The accidental juxtaposition has always been an inspiration in all aspects of my design work, and sketching is a useful tool for imposing some sort of order onto the chaos."

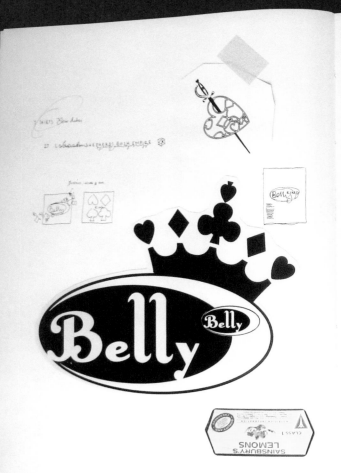

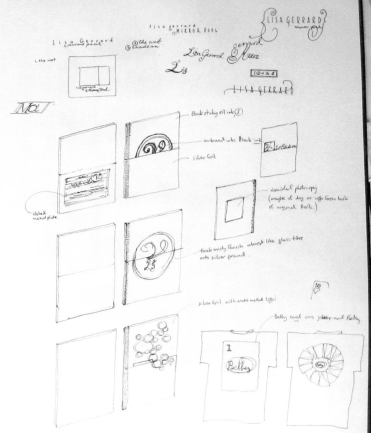

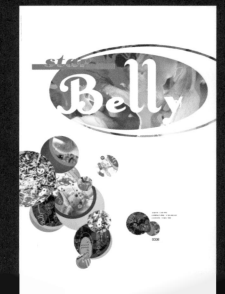

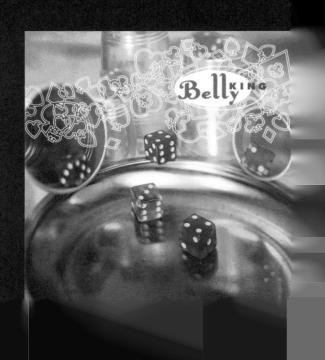

Belly [ALBUM]

[Dancing] dVine.
DANCING alvinecall alvine.

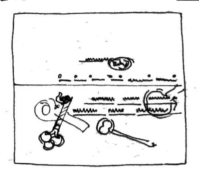

Belly
Music Packaging

4AD Records

"Belly's drummer, Chris Gorman, was also a photographer, and he had sent a huge pile of images, not in one huge go, but a constant flow of bits and bobs. Normally, when you hear the drummer went to art college, you say, 'Oh *no*,' but this was one of the best relationships with a band I've ever had—a true collaboration. It wasn't even art direction; my job was just to edit it and put it into some form of context. The band had given me a Holiday Inn logo as a reference, and many of Chris's photos featured spades and tumbling dice, so the artwork began to take on this Las Vegas vibe. The album title *King* came up after the band saw my initial visuals."
—Chris Bigg

"This was actually the first job I did on the computer—with some help, of course. Looking at it now, I wouldn't tuck the title typography over the logo. The first record, *Star*, still feels fresh to me; I don't think *King* is quite as strong. *Star* had almost accidentally become really big, so there was a lot of tension involved in the follow-up."
—Chris Bigg

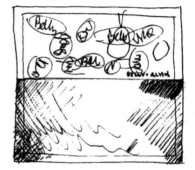

[ULTRA VIVID SCENE]

[ULTRAVID SCENE]

Unrest
Music Packaging

4AD Records

The 13 Year Itch
Music Packaging

4AD Records

"The Unrest record and the 13 Year Itch both happened about the same time. The 13 Year Itch was a series of concerts celebrating 4AD Records' thirteenth anniversary. Even at the sketch stage, before we knew which image we were using, we felt that bringing a lot of different typefaces together could work and perhaps reflect all the different bands that would be playing. It's interesting to see how it whittled down to just a few typefaces.

Because this wasn't for one band who would have their own ideas and identity, there were no boundaries. Ivo Watts-Russell, the label head, had basically said, 'Do what you want,' so there was a real flurry of activity in the studio. The use of very bright colors was quite different to the other work we were doing at the time. Ivo had recently moved from London to Los Angeles, and he was always talking about how bright and colorful everything was over there; and that somehow translated into a brighter palette.

I shot the word itch on the PMT camera by reducing it really small and then blowing it up again through a dot screen. I was really proud of that; it was the first time I'd done that. I remember Ivo really liked the bulgy top of the C—that was a mistake, but he was really into it. He also came down to the studio one day and said, 'You have to put *shuffle* on there somewhere. I don't care where, just as long as it's on there.' I never really knew why."

—Chris Bigg

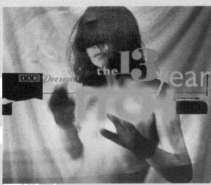

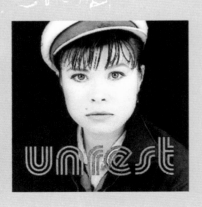

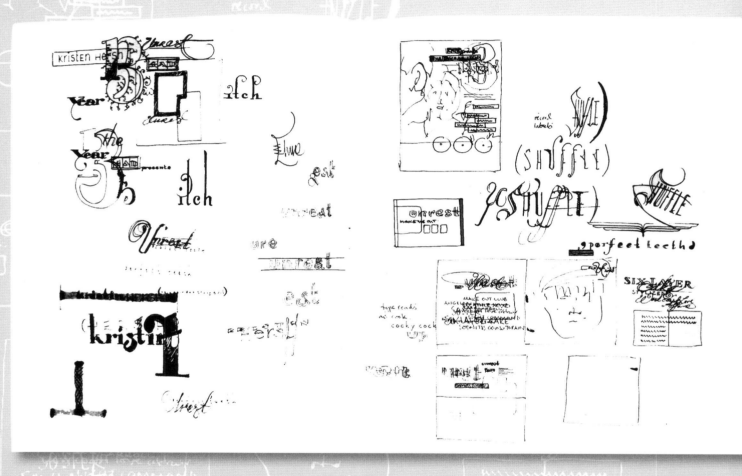

Art direction and design by Chris Bigg/v23
Artwork adapted by Coudal Partners
Photograph by Bryan Bedell

"Dead Can Dance was the first project Vaughan handed over to me. They always had very strong ideas regarding typography and imagery, but after a number of projects I won their confidence and was able to introduce elements of my own.

I had always wanted to design a logo for them and had spent years presenting various sketches—with no success. This logo for their 2005 reunion tour is, I feel, quite an extreme solution, as the second d is laterally reversed.

The dragonfly wings I found in my garden. I was struggling for an image and had presented many landscapes and moods, to no avail. I was surprised at how well they scanned. I love the fine detail within each segment of the wing structure."

—Chris Bigg

Dead Can Dance
2005 Tour Logo

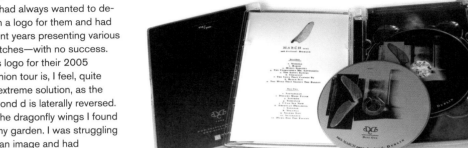

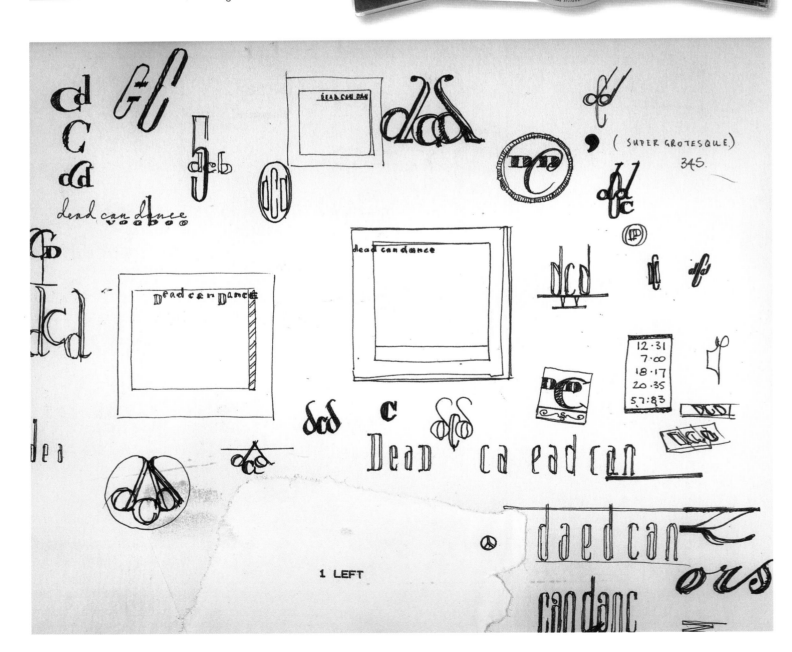

Miscellaneous sketches

"I have a quite chaotic and racing mind, and sketching helps me impose some order on my thoughts. I especially like to sketch in the morning, in that early, lucid period."
—Chris Bigg

Nigel Holmes

Westport, Connecticut

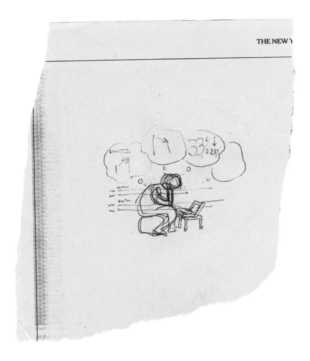

From: Tom Acitelli <tacitelli@observer.com>
Subject: **Lab chart material**
Date: March 7, 2008 1:28:22 PM EST
To: nigel holmes <nigel@nigelholmes.com>, Nancy Butkus <Nbutkus@observer.com>

The column is about the rise of the creative classes in Brooklyn and the odds they're up against real estate—

HED: Hey, Man, Can You Spare $800 a Square Foot
DEK: Brooklyn Real Estate and Creative Employment Stats

33.2% increase in number of self-employed creative freelancers in Brooklyn, 2002-05
28% of all city's creative freelancers lived in Brooklyn by 2005

Office space
Vacancy rate:
9.7% -- 2006
8.9% -- 2007

Asking rents:
$25.64 per foot – 2006
$26.29 – 2007

Housing
Median price, condos & co-ops:
$550,000 – 2006
$590,000 – 2007

Median price, one-family townhouse:
$1,536,000 – 2006
$1,581,000 – 2007

Tom Acitelli
Senior editor
The New York Observer
212.407.9307 (office)
347.524.5017 (cell)
tacitelli@observer.com
AIM: Tjacitelli
www.observer.com

Nigel Holmes spent nearly two decades as graphics director for *Time* magazine, creating pictorial explanations of complex subjects, and was largely responsible for the explosion of interest in what he calls "explanation graphics." Since beginning work on his own in 1994, Holmes has explained things to and for clients including Apple, Fortune, Nike, the Smithsonian Institution, and Sony. He has lectured widely and is the author of multiple books, his most recent being *Nigel Holmes on Information Design*, a book-length discussion with Steven Heller.

HOLMES'S HOMEMADE SKETCHBOOKS—made of whatever paper is handy inserted into a blue file folder cover—are densely packed and contain detailed schematics, caricatures on Post-Its, and notes for lectures and presentations. At the time of my visit, Holmes was busy working out how to make a three-dimensional bar graph out of a roll of toilet paper attached to helium balloons for an upcoming seminar. Here he speaks eloquently about the role drawing by hand has played in his long career.

"Something happens between the brain and the hand that I do not believe happens between the brain and the computer (with your hand and mouse in between). Of course, people tell me this is an old-

$800 / sq. ft.
£532/0.09m²
Information Graphic

New York *Observer*

"Every week I do a graphic for the real estate section of the New York *Observer*. Although the data is always some statistical aspect of the New York City real estate market, Nancy Butkus, the art director, wanted the pieces to be less chart-like and more illustrative. This would bring a bright graphic element to pages that were otherwise filled with pictures of buildings or developers. I get the statistics on Friday evening, and Nancy needs the final art some time on Monday.

This piece was about creative freelancers and the high and rising cost of housing and office space in Brooklyn. My first thought was to use Rodin's 'Thinker' as a metaphor for creative people, but when I drew it, the shapes were too complicated for a background to the bar graphs (sometimes you need to carry a thing through to find out it doesn't work). I went with something that was a mere scribble in my sketchbook—more of a note to myself rather than a sketch: It was the somewhat cliché light bulb to represent creative ideas. But it made a more arresting, simpler picture; it didn't interfere with the chart material; and it allowed me to insert the image of a woman into the usually male-dominated section.

I usually put ideas into my sketchbooks quickly, however inconsequential they might be. In this case, the sketches helped me to get past one cliché to another!"

—Nigel Holmes

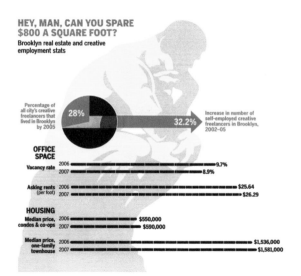

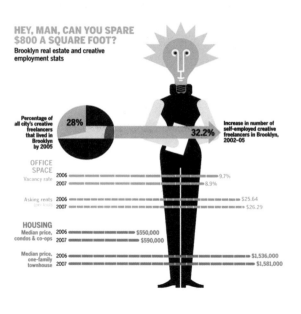

fashioned notion: A whole generation is here that literally grew up using computers for everything. They may never experience what I'm talking about, but I'm still convinced that one can think more clearly without a digital intermediary: It's pure thought to paper, without any suggestions from the endless file of templates or ways of constructing a drawing that are just sitting there in the computer waiting to tempt you to try them.

"I start everything on paper and only go to the machine when an idea is pretty well worked out. I do leave something to be discovered, just so I am not reduced to a machine myself, simply going through the motions of reproducing the idea in finished form. And I often fail in some respect to carry out the idea as well as I had thought I would be able to.

"Nowadays, I seldom show a hand-drawn sketch to a client. This is partly because my stuff usually has a text component that's at least as important as the visual. I'll set the words on the computer so a client can read the proposed text, even if it's rough or will need editing later. Having done that, it makes sense that if the text looks real, the drawing should be in the same format.

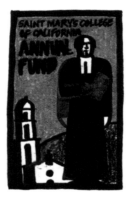
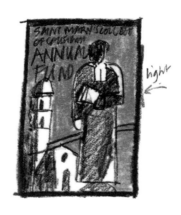
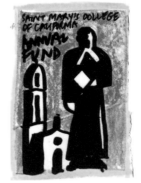

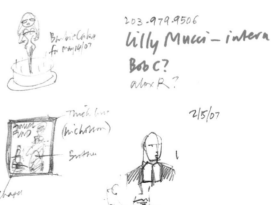

"I think the advent of the computer greatly damaged the art of illustration 20 years ago or so. Good illustrators were sucked into the new electronic fad. At the same time, magazines started to ask for everything in digital form. A lot of work started to look the same, but over the years, many illustrators have made elegant transitions to digital work. They have kept their own idiosyncratic styles, making the computer do their bidding rather than being led by it to a showcase of special effects previously impossible to achieve by hand. Affordable scanners have allowed other illustrators to paint and draw directly in whatever medium they want and still satisfy the commercial and technical wishes of their clients.

"For me, drawing on a computer is not that different from the way I drew before 1984. First I sketched; then I tightened up the sketch on tracing paper; then I put a piece of clear acetate over the tracing and drew the final with french curves and straight-edges—there were no freehand lines at all. I'm not against computers—I could not exist as a practicing information designer without one—but before I ever used one, and still, to this day, the sketch comes first."

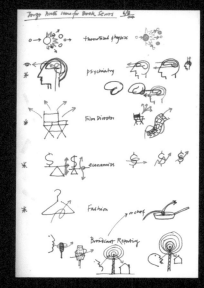

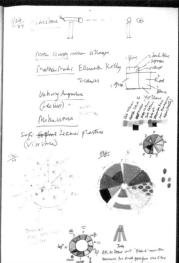

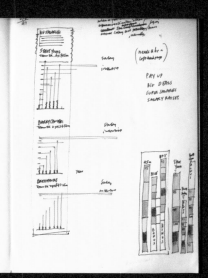

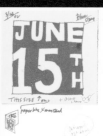

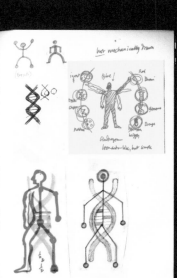

10/26
05

25 R/L Brain · R/L Brain

25 curiosity · curiosity

· Humor 5

25 drawing · passion 10

· Computer skills 2

· long hours

Drawing
writing · R/L Brain

· history
Journalism
passion
humor
computer
skills · Curiosity
Journalism
observation

history

Split
Journalism aesthetic

Journalism
Curiosity
drawing/writing · humor

What It Takes to Be an Information Designer

A Self-Portrait

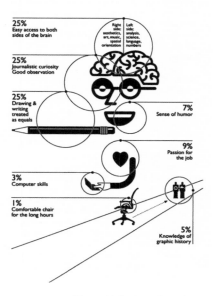

| 25% Easy access to both sides of the brain |
| 25% Journalistic curiosity Good observation |
| 25% Drawing & writing treated as equals |
| 7% Sense of humor |
| 9% Passion for the job |
| 3% Computer skills |
| 1% Comfortable chair for the long hours |
| 5% Knowledge of graphic history |

Right side: aesthetics, art, music, spatial orientation | Left side: analysis, science, language, numbers

"Steve Heller interviewed me for a book about my career. It was one of a series of books intended for college-age readers. The format of the series was traditional and text-based, with no illustrations or color. But it seemed odd not to have any visuals in a book about design, so I created a couple of simple line diagrams in black and white that addressed my own working methods (and that would reproduce well enough on the paper used for the book.)

This one is a humorous attempt to quantify the attributes I think are important for an information designer. It takes a mild jab at what I consider the overrated expertise in computer skills that seems to dominate teaching of design (I give it 3 percent—very little importance). The diagram is a self-portrait of sorts, and it reflects much of the Q&A Steve Heller and I had in the book itself. It took a few tries to get the image right—all worked out on paper before touching the computer."

—Nigel Holmes

Rob O'Connor /
Stylorouge

London

Mor Karbasi
Music Packaging

Mintaka Music

"Logo sketch for a London-based singer-songwriter of Moroccan/Persian Jewish parentage. It is florid but legible, with a hint of a Hebrew feel (she sings in Spanish and Ladino, an ancient Jewish language). The photography for the final sleeve is by me."
—Rob O'Connor

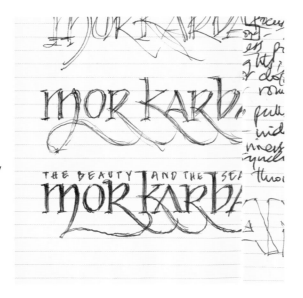

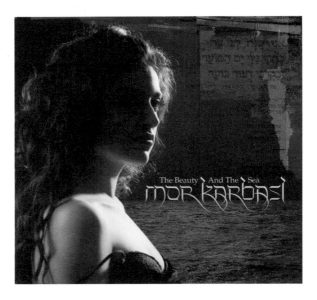

If Stylorouge has been occasionally eclipsed over its 25+ years by more notorious music packaging firms and has never experienced the heady rush of sudden, explosive success, neither have they suffered a drop in commissions as tastes and trends have changed. This is in large part due to its intentional avoidance of a house style, preferring to place the individual needs of the artists first.

"I BELIEVE IT was John Gill who said there's never been a great design that couldn't be verbally explained in a couple of sentences," says Rob O'Connor. "This may be an exaggeration, but it highlights the need to be a good communicator—in any medium. The combination of describing and illustrating your thoughts in a cohesive and persuasive manner is the best way to instill confidence in a client."

"Sketching is as cathartic as it is potentially creative," he says, and acknowledges that beyond the sheer enjoyment of mark-making, his sketches are largely an extension of his meeting notes. "They're my initial thoughts about a project. Even if I know at the time that they're wrong, by getting them out in the open,

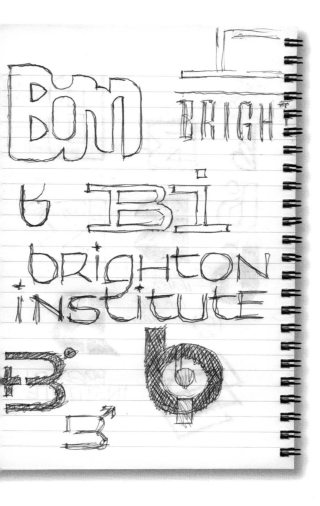

BIMM
Identity

**British Institute of
Modern Music**

"These sketches were initial thoughts for a logo for BIMM, a contemporary music school originally based in Brighton. The client wanted to avoid clichés related to Brighton and its cultural and musical history. We started working mainly typographically, and I was trying to emulate from memory the cool corporate style of 1960s U.S. design, but the final design for what has now become the British Institute of Modern Music shows how we ended up veering toward the mod scene that is synonymous with the pop culture of Brighton."

—Rob O'Connor

I'm clearing space in my mind for other stuff that may be less obvious. I don't think I doodle idly; I'm happier investigating possible solutions to a creative brief and objectively studying the outpourings later, and deciding whether they really work or not. The first time an idea makes it onto paper is a good initial test of how a final design may look, and this can sometimes be the most exciting stage of a project."

Having painstakingly created multilayered images out of "transparency sandwiches" in Stylorouge's early years, O'Connor is no traditionalist pining for the hands-on days of rubber cement and drawing boards. However, "committing my thoughts to paper is an absolute necessity for me—my memory is possibly the most unreliable tool in my box," he says. "But there are certain things that are best created on a computer. I do find, though, that being able to draw has been a huge benefit—and when it's done in front of a client, that can be a winning party piece."

Kula Shaker
Music Packaging

Columbia Records

"*Peasants, Pigs, and Astronauts* was the second (and final) studio album by English psych-pop-rock act Kula Shaker before they split and then re-formed. Their interest in classic 1970s album art and late 1960s U.S. garage punk went hand in hand. The original brief for the album sleeve was to combine the sense of physical and metaphysical travel. Early ideas submitted to the band threw up a theme when we all enjoyed a historic woodcut illustration we found of 'the ship of fools,' an inhumane approach to exiling members of the community with psychiatric problems by casting them adrift on an arklike boat. This developed into the idea of a historic astral traveller—a character apparently from medieval history who had the ability to travel in space and time. (Yeah, I know. Personally, I was only under the influence of Harveys Bitter at the time.) The notebook shows the first sketch for a complete medieval/alien/astronaut font design that went almost to final art before the band had a change of heart."
　　　　　　　　—Rob O'Connor

Photography by Jeff Cottenden. The guy in the astronaut suit is the esteemed author of this book.

Christophe Willem
Music Packaging

SonyBMG Records

"Some of the initial sketches for a campaign to launch the recording career of Christophe Willem, winner of the French equivalent of American Idol. His marketing graduate status and his own penchant for camp and irony set him intellectually above the level of the great majority of pop wannabies, and we joined in the fun, helping him present himself as 'Product of the Year.'

The album title changed to *Inventaire* but the image remained intact; the dressed-down, reluctant hero portrayed as the centerpiece of a pompous aristocratic seal made out of images of a showgirl. Even I can't fathom how we arrived at the absurdity of the final image, but the album went to number one in France and we drank a small amount of champagne."
—Rob O'Connor

Photography by
Sandrine and Michael.

Gabriela Montero
Music Packaging

EMI Classics

"Gabriela Montero is a South American classical improvisational piano genius, signed to EMI Classics in the UK, for whom I wanted a hand-drawn logo—nothing fancy, just something with femininity and a touch of the latin and the baroque. The album is a collection of her let-loose creations based on the music of Scarlatti, Vivaldi, and so on. The sketch is a typical bit of doodling on the train home from London Bridge to Paddock Wood. The final logo art was drawn at Stylorouge by Anthony Lui."
—Rob O'Connor

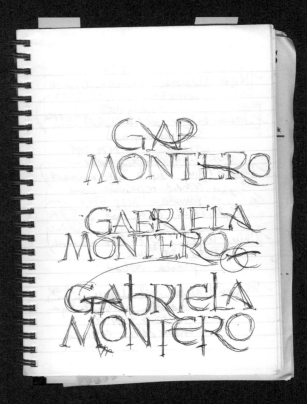

Miscellaneous sketches

"Various stuff, most of which wasn't used.

Zone 2000 was a projected community youth festival in South London. Demon Music developed into the music company's corporate ID.

Regarding the T-shirt-shaped stuff, well, ideas for T-shirt designs and slogans are constantly jotted down, as we do a couple of ranges each year."
—Rob O'Connor

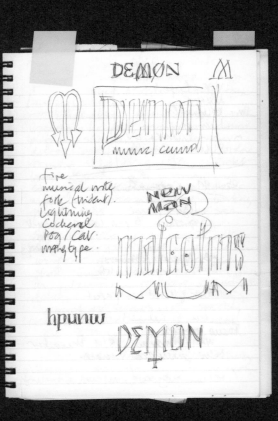

"The Cure's Robert Smith approached me with an idea for his greatest hits package, and immediately warming to the potential for a little lo-fi handmade eccentricity, I volunteered myself to take the photographs. I showed him nothing more than a couple of the worst-drawn sketches I've ever seen, let alone done, to make sure we were on the same page visually, and went about building a set that was part décor for a cheap nightclub and part juvenile nativity play. Final typography was by Andy Huckle for Stylorouge. The shots that were taken were reinvented as a one-off print in 2007 to be sold at a music business auction event in aid of the charity Cancer Research at London's Abbey Road Studios. Both Robert and I signed the final print, but I think it was his signature that attracted the £1,000 bid."
—Rob O'Connor

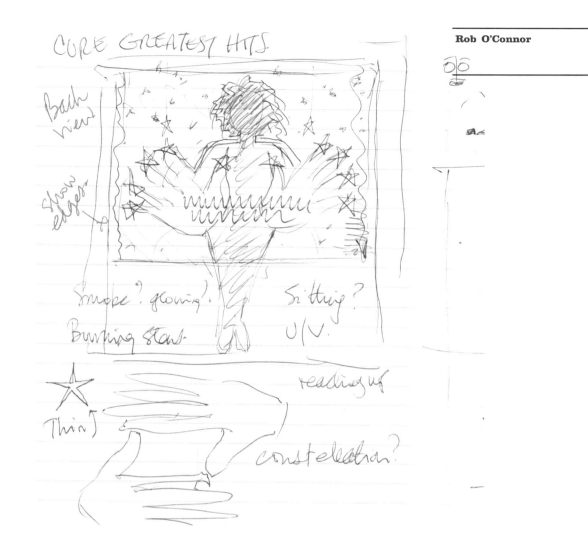

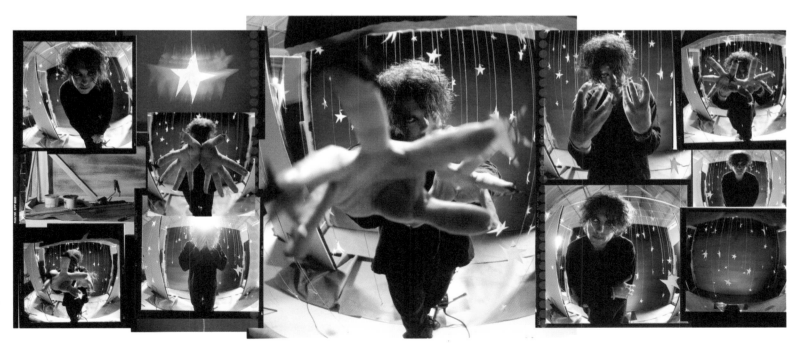

Davor Bruketa / Bruketa & Zinic

Zagreb, Croatia

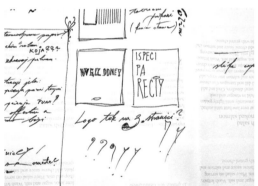
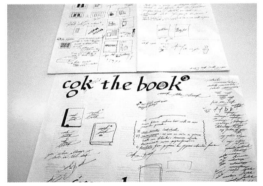

Bruketa & Zinic, established in 1995 and based in Zagreb, Croatia, has received more awards than any other advertising agency in the region. Their services include communication strategy, advertising, branding, packaging design, and interactive media, and their work has appeared in *Grafik* magazine, *Print* magazine, the *New York Times, I.D., How,* and the Art Drectors Club Annual.

"WE OFTEN BEGIN projects by sketching informally," says creative director Davor Bruketa, "in addition to cutting and pasting found material together and researching typography and imagery on the computer." In discussing their work for longstanding client Podravka, he says, "This is the eighth annual report we've designed for them. By now, we're very familiar with the brand and have a clear idea of how to convey their basic business messages to their stockholders, clients, and business partners—so we're free to spend more time just having fun with the material. We're always trying to interpret Podravka's slogan, 'The company with heart,' in a different way."

"This is an annual report for Podravka, the largest food company in Central and Eastern Europe. Podravka's logo is the heart, and their corporate slogan is 'The company with a heart.' With this piece we wanted to show the relationship between the heart, warmth, and Podravka.

The annual report consists of two parts: a large book containing financial figures and a report of an independent auditor, and a small booklet inserted inside the big one. The smaller booklet contains the very heart of Podravka as a brand: great Podravka recipes.

All of Podravka's products must be baked before use. That is why the small booklet is printed in invisible, thermoreactive ink. To be able to reveal Podravka's secrets, you need to cover the small booklet in aluminum foil and bake it at 212°F (100°C) for 25 minutes. If you are not precise, the booklet will burn, just as any overcooked meal. If you successfully bake your sample of the annual report, the empty pages become filled with text, and the illustrations of empty plates fill with food."

—Davor Bruketa

Ayse Birsel and Bibi Seck / Birsel+Seck

New York

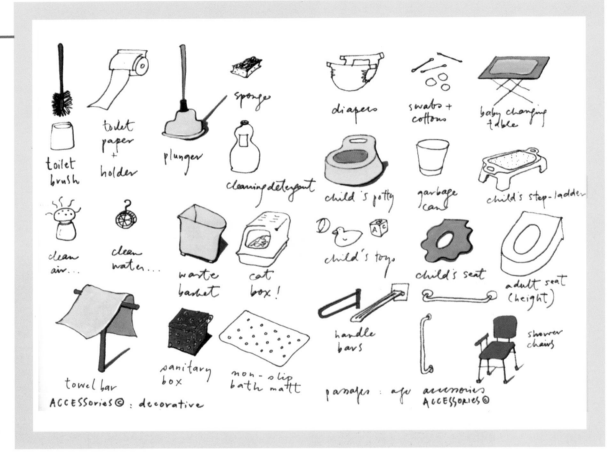

Product designers Ayse Birsel and Bibi Seck met while working on a Renault automobile interior in 2002. Since then, their collaboration has blossomed into a highly fruitful partnership as Birsel+Seck (not to mention marriage.) Their work for corporations such as Hewlett-Packard, Target, and Herman Miller—including their NeoCon Best of Competition-winning "Teneo" storage system—is surprising and innovative, but always remains focused on its end-user.

"DRAWING IS REALLY a language to me—my first language," says Birsel. "As a child, I learned to draw around the same time I was learning to write. In terms of thinking, it's as much a form of expression to me as speaking or writing. Sketching allows me to organize my thoughts; the clearer my thoughts, the simpler the sketches become. At the beginning of a project, they've very messy, as I'm searching for a solution and don't yet know what to think. As I get the hang of it and I find the hook that gets me toward a solution, the sketching gets clearer and clearer. If I need to, I'm capable of doing very detailed sketches, but I really like the conceptual sketches, where it's not so much the form of the product but the concept and the solution to the creative problem."

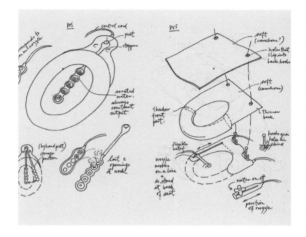

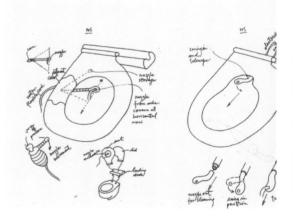

Bibi Seck was lead designer at Renault for twelve years before his partnership with Birsel. He remembers sketching cars constantly as a boy, "and I never stopped." For Seck, sketching is an intensely personal and powerful, even potentially dangerous, act. "I don't draw to communicate my thinking to other people— it's more a mirror of myself. As soon as I have the idea complete in my head, I stop drawing. It's already there. Drawing is like a cane, something I use for support while I'm thinking."

Generally, the pair sketch separately but alongside each other until eventually curiosity gets the better of one of them and he peeks over the other's shoulder. However, each project unfolds differently. "Once, when we were working on a table collection for HBS,

I sent Bibi some scans of my sketches; mainly to show him I hadn't been goofing off in his absence," recalls Birsel. "He called me and said, 'Send me the sketch on the other page.' On the scan, he could see the other side of the page bleeding through, and that image became the starting point for the collection. There's something nice about working together. We see things the other doesn't see in his own work; we spark ideas back and forth.

"We sketch in order to think; the core of our ideas are captured in our drawings. If Bibi and I were asked where an idea came from, we would show our sketchbooks."

Zoë Washlet
Product Design

TOTO

pocket
shirt

中

02062006
withmka

White Shirts
Fashion Design

Bils

"In 2006, we designed five new shirts for Bils, a textile company in Istanbul. Our clients, Selman Sinha and Derya Bilsar, informed us that as long as the shirts were white we could design anything we wanted, and they would make sure they happened. So we did—starting with a black shirt. We called it the Black Sheep, and no one objected. Derya and the seamstresses at Bils produced complex patterns for the line that were shaped and contoured precisely as we had imagined them. They then asked us if we would mind being photographed wearing the shirts. Since we were in Dakar at the time, Bibi thought it a good idea to take the pictures there.

Which led to our meeting Bonbacar Touré Mandémory. When we asked Bonbacar if he had his book with him, he pulled out a mammoth tome from his bag. The book was called *Snap Judgments*, and it profiled an exhibit of the same name that featured his photographs at ICP in New York City last spring. The gallery, as fate would have it, was located just a few blocks from our midtown office.

While Bonbacar graciously waited for us to flip through the pictures, and as we recognized beautiful image after beautiful image, we felt those months of designing the shirts were a pretext leading us to Bonbacar and the chance to work with him. We met the next morning at 7:00 a.m., and with the shirts in our arms and Mandémory with his cameras in his bag, we took a taxi to the Corniche. With jogging young men and meditating elderly marabons as our witnesses, we posed."
—Ayse Birsel

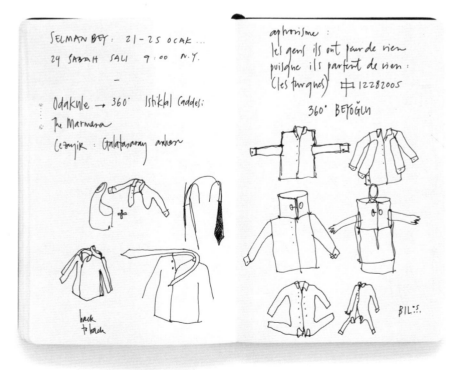

kırk
ayak

her işte bezi var

中

02062006

black
sheep

中

02062006

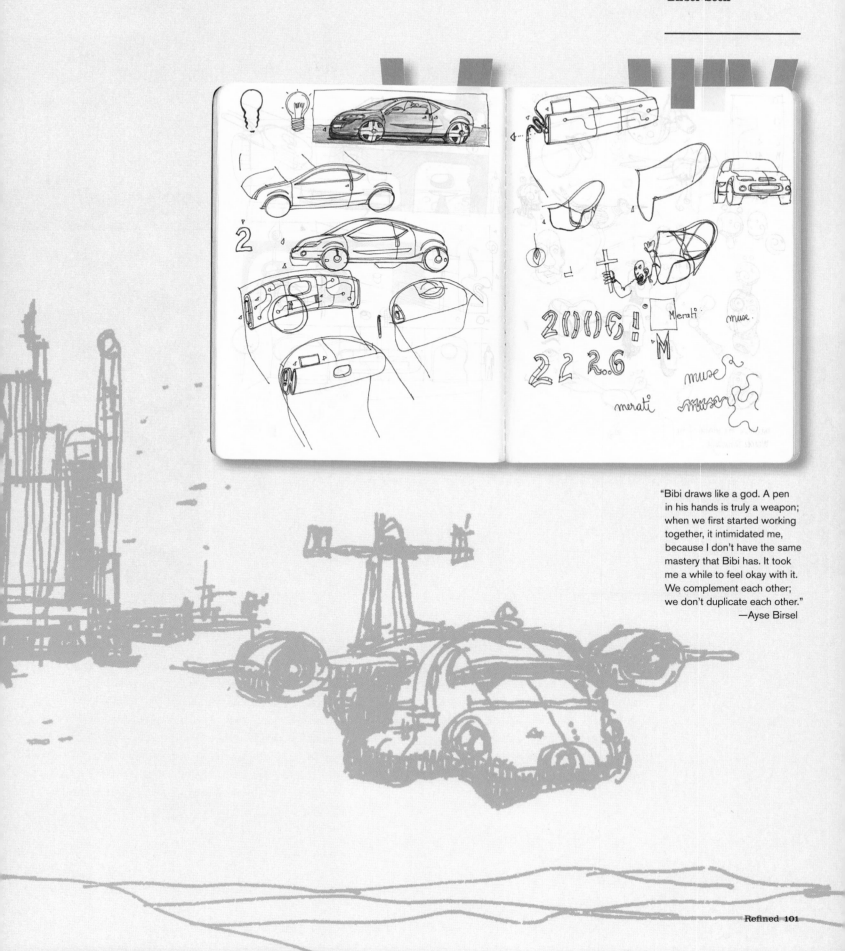

"Bibi draws like a god. A pen in his hands is truly a weapon; when we first started working together, it intimidated me, because I don't have the same mastery that Bibi has. It took me a while to feel okay with it. We complement each other; we don't duplicate each other."
—Ayse Birsel

Pablo Rubio Ordás /
Erretres Diseño

Madrid, Spain

Founded in 2002 by Pablo Rubio Ordás, Erretres Diseño specializes in branding, editorial design, multimedia, and graphic design. Their principal clients include the Prado Museum, Barceló Hotel and Resorts, and Universal Music. Rubio is also the art director of the acclaimed _Matador_ magazine as well as the director of the masters program in branding at the European Institute of Design in Madrid.

ACCORDING TO PABLO RUBIO ORDÁS, "It depends on the individual, but we generally sketch with a pencil in Moleskines or on plain paper. Waiting rooms and at home are good places to sketch. In the studio, it's common to move away from the computers to sketch in a technology-free zone. The computer gives you the opportunity to improve your idea, and sometimes the final layout is better than the first idea. If you have a great idea, it's a question of experience, time, and skill to achieve a great result."

Rubio sees sketching as a direct link between the mind and the hand. "Sketching on paper is pure idea," he says. "With the hand, there are no computer tricks. The hand doesn't lie." In addition, he notes, "Sometimes sketching is the fastest way to communicate with a client in a meeting or with other designers in the studio."

"These three proposals for the Christmas 2009 shopping bag for the legendary shop Vinçon were developed in collaboration with the creative think tank Nadie. Vinçon has often commissioned famous designers or artists, including Mariscal, Pati Nuñez, América Sánchez, and Barbara Kruger, to design its bags. The final selected design was the bag with a snowflake made out of palillos (toothpicks), a typical Spanish gadget for eating tapas. The sketches were drawn in a hospital waiting room two weeks before the birth of Olivia, my first child."

—Pablo Rubio Ordás

Vinçon
Collateral Design

Vinçon

Design: Erretres.com/Nadie.
Sketches: Pablo Rubio Ordás.

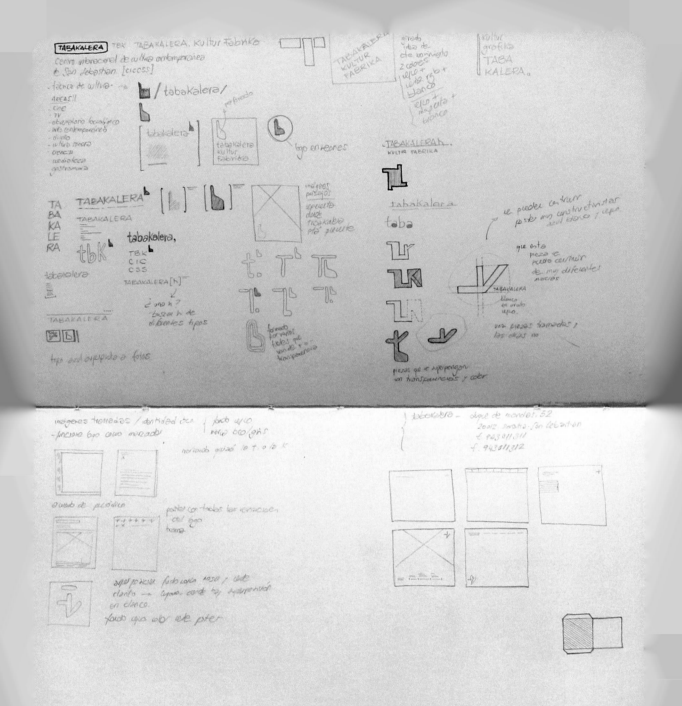

Tabakalera
Identity

"Erretres was selected to participate in an international contest to design the identity of a new center of cultural creation in San Sebastián. The center is situated in a former cigarette factory and will be in part dedicated to promoting audiovisual creation (exhibition, learning, creation, etc.). The sketches were drawn by Gema in the studio."
—Pablo Rubio Ordás

Art Director: Pablo Rubio Ordás/ Erretres.com.
Design: Gema Navarro & Daniel Barrios.
Sketches: Gema Navarro.

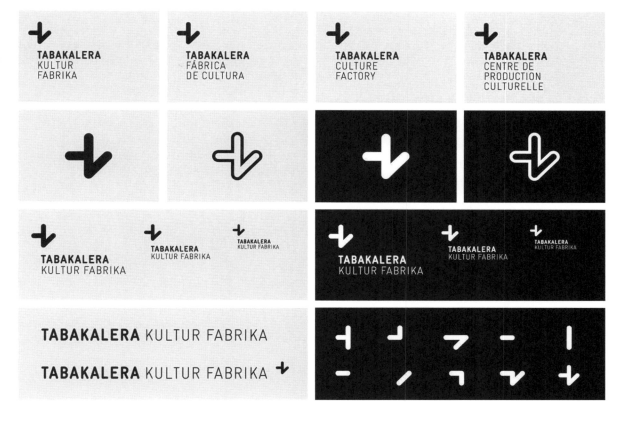

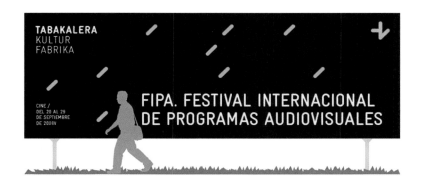

Marian Bantjes

British Columbia, Canada

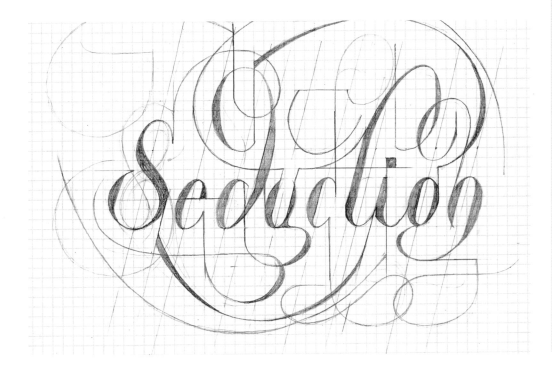

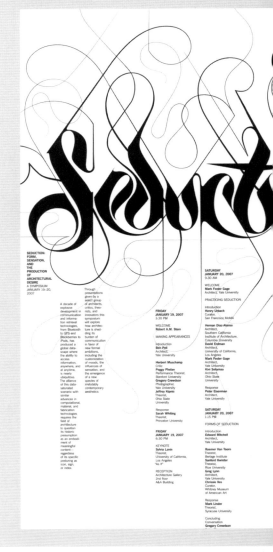

Graphic artist (or "lapsed graphic designer," depending on her mood) Marian Bantjes is internationally known for her highly ornate and expressive typography, usually rendered as precise vector art but occasionally executed in oils, ballpoint pen, and even sugar for clients including Pentagram and Sagmeister, Inc.

"I THINK WITH a pencil in my hand," says Bantjes, "and every time I've tried to take a shortcut, I end up with something stilted and unnatural, and I literally have to return to the drawing board."

Having started her career as a book typographer, Bantjes brings that discipline's structure and precision to her organic letterforms, usually drawing only one or two pencil sketches before moving into final art. "I am not a sketchbook person," she says. "I wish I was—I wish I had continuous sketchbooks where you could follow the chain of time. I always take paper or a sketchbook with me when I travel, but seldom use it. I can't think away from home."

The Yale
School of
Architecture
is a Registered
Provider with
The American
Institute of
Architects
Continuing
Education
Systems.
Credit earned
by attending
this symposium
will be reported
to CES Records
for AIA members.
Certificates
of Completion
for non-AIA
members
are available
upon request.

Seduction
Poster

**Pentagram / Yale School
of Architecture**

"When Michael Bierut hired me to do the 'Seduction' poster for the Yale School of Architecture lecture series, he said his client had asked for something 'pretty pretty' and had also supplied some strange, alien pod-looking architectural drawings. Michael asked for something voluptuous. He said, 'Don't be afraid to make it a little bit sick.' So at first I kind of had too much input. I was a little confused, and I tried a few things that were quite different. I was trying to incorporate straight lines for architecture, and some of the alien pod things, and it was all just a little bit out of control. I took a little break from it, and then decided to focus on 'voluptuous' and 'sick,' which is where the type that was developed and used came from. Originally, the very fine lines that came from the type were piercing the type, like needles, but that all got kind of merged together in the final.

The funny thing about this piece is that I didn't have a really true sense of it until after I got the printed poster back. I had seen a .pdf file with Pentagram's placement of the informational type, which I was thrilled with, as it was exactly how I would have used the 'Seduction' type for alignment, but when I got the poster I was really floored. It just looked so much better than I had imagined. I think the poster is pretty rare, by the way. I only have two copies myself; I had three, but I gave one to the Cooper Hewitt."
—Marian Bantjes

Bantjes reworks her sketches on graph or tracing paper until they're ready to be scanned into Illustrator to trace. A point of honor for her is that she never uses Illustrator's autotrace function. "I trace Bézier curve by Bézier curve, and then adjust everything obsessively."

Surprisingly, given her mastery of letterforms, she does not have a background in calligraphy. "That part of my development is somewhat of a mystery to me. It happened spontaneously about a year after I left my design business. I don't really know how. I'm practically useless with a pen or brush."

"There's just something about pencil sketches," she adds. "When I was a typesetter, we used to receive pencil layouts from the designer, where they would have drawn in the headline type and marked it up for size and spacing. I always thought the final phototypeset piece was not nearly as nice as the pencil sketch. I love my sketches; they just have something the final work doesn't."

Want It!
Campaign

Pentagram / Saks Fifth Avenue

"The Saks 'Want It!' campaign was pretty straightforward in terms of lettering style in that it needed to go with the existing Saks logotype, but with, as Michael Bierut put it, 'more swing.' The Saks logo is a very stiff and formal Spencerian script, so I started there, redrawing it by hand, and then moved away from it as much as I dared.

The more interesting part was the direction for the rest of it. For the Want It! logo, they wanted it to be this crazy, energetic feel. Basically I just kept adding more and more swirls until they had enough. I actually really hate just drawing swirly things. I find it intensely boring. Terron Schaefer at Saks asked for the feather—I really think he wanted something Saul Steinbergian overall, but

Michael wanted it in keeping with the logo—which I resisted like crazy, but the client won in the end.

Things got much more interesting for me when we did the 18 Want It! items, when it became apparent that Terron wanted the items to look like the words, so 'Textured Cardigan' would look like a textured cardigan, 'Tuxedo Dressing' would look like a tuxedo, etc. At that point, Michael Bierut handed me directly over to Terron at Saks, and we worked together with a lot of back and forth. Some of them were easier than others. Some went through round after round. A couple of them were not specifically things, like 'Winter White' and 'Shine.' I had a helluva time with 'Shine,' though my eventual solution seems perfectly obvious. It was challenging, but that's what made it fun for me. And Terron is such a great person to work with. It was really a good experience.

In the end, I handed over the vector files and I didn't see it again until first it started appearing in magazines, and then when I walked in the store in New York, it was applied to so many different things in so many different ways—it just blew my mind."

—Marian Bantjes

Cape

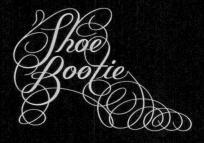

Textured Cardigan

Shoe Bootie

High Heel

Gentleman's Bag

Novel Tie

Winter White

Cropped Jacket

Extra Long Lace-up

Tuxedo Dressing

Dramatic Lash

Shine

Michael Bierut / Pentagram

New York

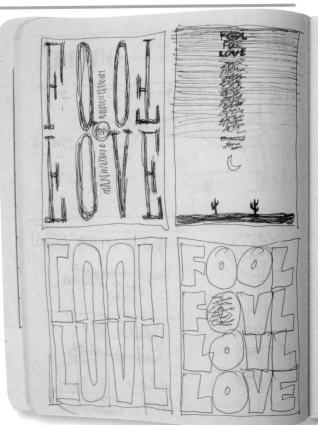

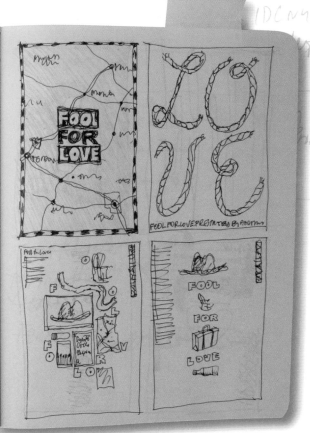

Michael Bierut, a partner at Pentagram's New York office, has produced acclaimed work for clients including United Airlines, the Walt Disney Company, the *New York Times*, Motorola, and Saks Fifth Avenue. A founding writer of the widely read Design Observer blog, he is a member of the Art Directors Club Hall of Fame and in 2008 received the National Design Award for "Design Mind."

MICHAEL BIERUT is one of the graphic design world's most prolific figures. He has won hundreds of awards at both Vignelli Associates and Pentagram, where he has been a partner since 1990, and is responsible for many examples of celebrated and recognizable graphic design. As a recent profile of Bierut by design writer Alissa Walker put it, he "has built his career on making himself, his work, his personality, his opinions, available."

Bierut has also made prolific use of sketchbooks, filling some 80 books since 1982. A fascinating secret history of a highly visible career, Bierut sees these books—all a uniform size, all with unlined paper—more as evidence of compulsive behavior, akin to his three-mile run each morning and the highly regulated charts that

detail his progress. "I take my current notebook with me to every meeting, even if I never open it. Each one works like a security blanket for me." Despite his admitted obsessive tendencies, Beirut's books are not buttoned up. "My books are messy. It's funny; I'm a fairly messy designer. It doesn't show in my work, but my process is messy. Sometimes someone will ask, 'Oh, we're doing a piece about process. Can you show us your design process?' And I know exactly what they want. They want this sequence of rough sketches leading to almost-rough sketches leading to almost-finished work leading to the final, chosen piece. I don't have those things; I don't work in a sort of methodical way.[10]

"I don't even consider what I do in these books sketching. It's more like note-taking. Sometimes the notes take the form of drawings or diagrams rather than words. I don't valorize drawing, and I really don't care if my designers sketch before they go to the computer. As long as they think before they go to the computer, I'm happy. Everyone has his or her own way of doing their thinking. These notebooks work for me. Besides", Bierut adds, "I've never learned how to design on a computer. A pen and a notebook are the only design tools I really know how to use with any confidence."

"Occasionally I'll run into someone whose name is familiar. In those cases, with alarming accuracy, I can go back to a notebook and pull out my notes from a meeting I may have had with them ten years ago. Nostalgia is too sentimental a term, but the notebooks definitely are memory aids."
—Michael Bierut

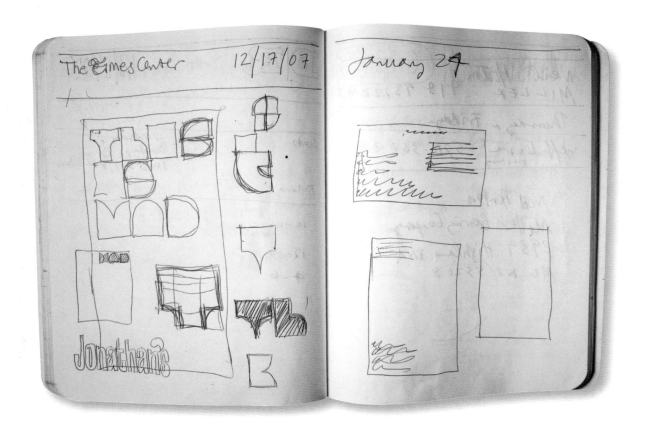

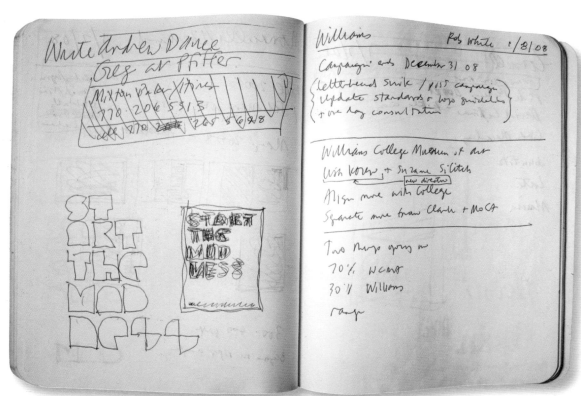

"The symbol is built out of circles and squares, a reference to the fact that this squarish building sits on one of the most prominent circles in New York City. The forms also refer in a subtle way to the building's distinctive, some would say notorious, lollipop columns, which are visible through the new façade."

—Michael Bierut

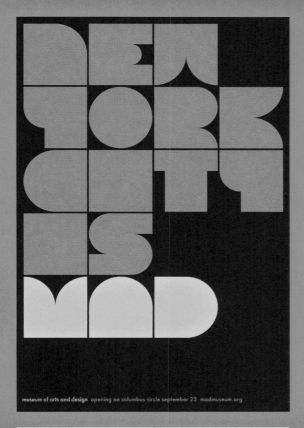

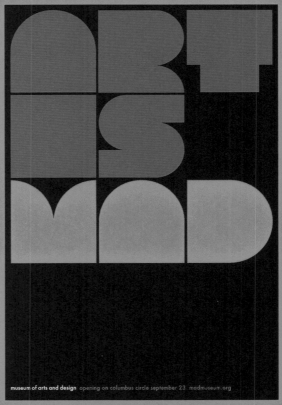

Aftermath

FRATELLI ROSSETTI

Opening
mine
can it match

12/7

Halley scope hours Michael B. 13.5 1012.5
Day 4 (0) qtts 180.0

November 1192.5

add'l to
Finish
mechs? $750-1250

2021 house production

S.C. Sign

250 "Sale"
 5×7"
 both sides

2000 Santa Cruz signs
 5×7
 both sides

$? How fast?
Dutch-around source!

Brian Taylor /
Candykiller

Dundee, Scotland

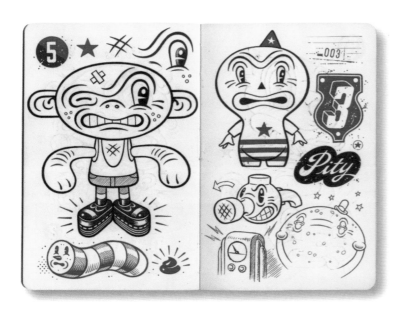

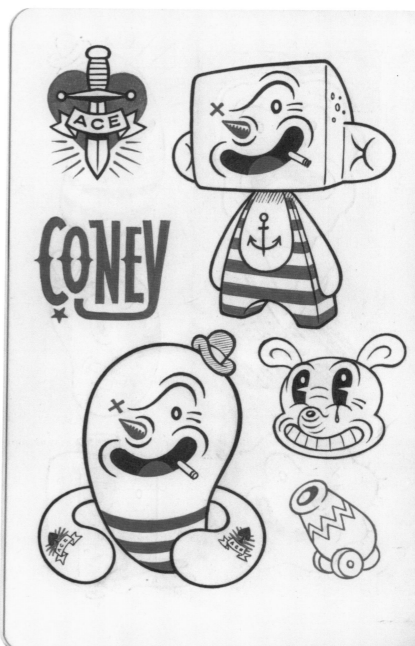

Brian Taylor's work under the Candykiller moniker blends the sinister and the adorable in an exciting range of vinyl toys, prints, and trading cards inspired by Japanese pop culture, 1950s comic books, and circus sideshows.

TAYLOR SAYS, "A LOT OF MY CANDYKILLER work is ultimately produced on the computer. However, pretty much everything I do starts out as a sketch. These are the steps I generally follow to produce a finished piece of work: I first work out my ideas in pencil in a Moleskine sketchbook. I then work over them in pen, refining the drawing as I go, then erase the original pencil work. If I feel an idea is worth following through to a finished piece, I scan the sketchbook drawing and use it as a guide to work over on the computer, refining it still further to achieve the end result."

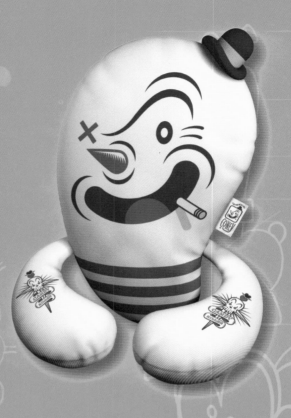

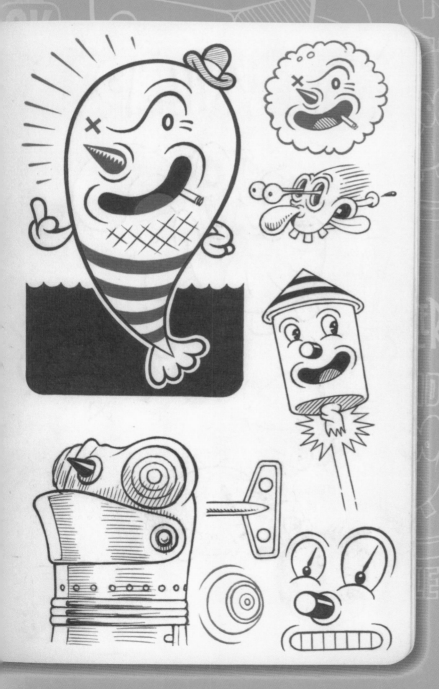

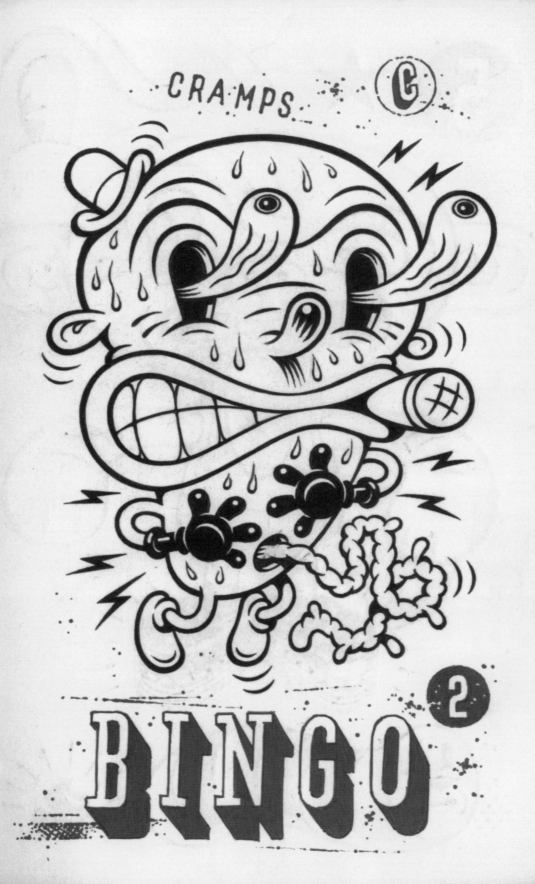

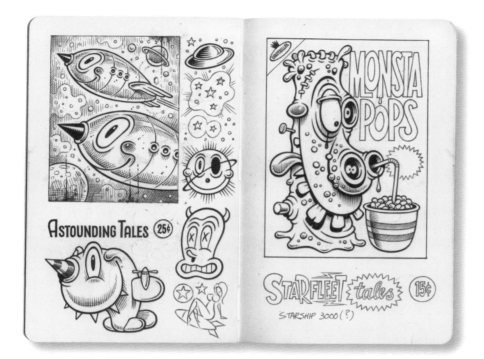

"Clients. . . . may find satisfaction in the unfinished quality of a sketch. . . . A sketch invites, or at least permits, the client's own contribution"

RALPH CAPLAN is a writer and communications consultant who lectures frequently on design and its side effects. He is the author of *By Design* and *Cracking the Whip*, a collection of his essays and magazine columns. Ralph Caplan teaches in the graduate program in design criticism at the School of Visual Arts.

Q+A/ Ralph Caplan
New York

Q To the outsider, sketches are fun, unconscious doodles, or, worse, art for art's sake. Sketching somehow doesn't count as work.

A The idea that sketching looks like fun, and very often is, makes it a mystery to anyone supposing that fun and work are necessarily in opposition.

Q With Blackberries and iPhones, we're jotting notes, managing our schedules, having phone and email conversations, and taking pictures all on a single device. Yet Moleskines and other notebooks remain incredibly popular in the design community. What do you think it is about sketching that is still so important to designers?

A Two points here, both important. I believe Moleskines and other similar sketchbooks are popular with designers largely because of their tactility. We like to fondle them. The really nice ones are downright intimidating—I have several notebooks I've collected over the years that I cannot bring myself to write in because my scrawl would violate the beauty of their paper. I am reminded of George Orwell's *1984*, in which the protagonist, Smith, finds a small old shop where he stealthily, almost guiltily, buys a diary that becomes a major player in the book, not only for the secrets he records in it but for the sensuous creaminess of the paper.

The other point is larger and has to do with the nature of the sketch itself. A sketch (often accompanied by the prefix rough) is by definition only an attempt to get an idea on paper, where it can be vetted for validity. Designers are anxious that they not be misunderstood by clients, and experienced designers know they are likely to be misunderstood much of the time. Two industrial designers I knew, Henry Dreyfuss and Jay Doblin, taught themselves to draw upside down so they could produce sketches at lunch that would be readable by someone across the table. I imagine many designers can do that. A sketch can forestall premature hostility to an idea by one's pointing out that it is "only" a sketch. Clients, too, may find satisfaction in the unfinished quality of a sketch. It is, after all, the perfect example of something that isn't carved in stone. A sketch invites, or at least permits, the client's own contribution.

Q You did something similarly unfinished with a series of publications called "Attention," "Connection," "Tension," and "Omission," and subtitled "Some Incomplete Thoughts with Room for Improvement."

A Yes, I did a series of notebooks, sketches, for Herman Miller. Certainly they were sketchy. The company's president had asked me to create a design magazine. I declined, pointing out that a design magazine published by a corporation would be suspect, and with good reason. Since most of what we do begins with notes that are refined and shaped as the idea develops, I proposed as an alternative that my notes be published as is, calculatedly half-assed notions, subject to anyone's amendments, including my own. They had to be clearly noncorporate—and were.

In fact, no one in the company saw them until they were printed. I owned the copyright, not Herman Miller. They had the desired effect, and for years whenever I went someplace to speak, designers would show me the notebooks, which they had made their own by writing and drawing their responses.

Q Have you noticed a shift in the way people use sketches as the field has become computerized?

A Not especially, but that doesn't mean that there isn't any. What I notice chiefly is that people use sketches less.

Q Why do you think that is?

A For one thing, fewer designers have been trained to draw. As long as I can remember, established designers have complained that design schools stopped emphasizing the ability to draw, and this complaint grew in validity as computers made up for the lack. A sketch is an attempt to see and to show what something might be like. For a more accurate version, you went to a model or mockup. But computers have become increasingly able to reveal such matters more fully than most designers can by hand, so sketching no longer has the priority it once had. Many designers lament this, and not just for nostalgic reasons. They feel something important is lost, namely the experience of thinking through a problem without mechanical intervention.

Q What do you think is the connection between the creative process and the physical action of the hands, whether it's sketching, writing, painting, or doodling in the margins of a notebook?

"The literary instinct may be known by a man's keeping a small notebook in his waistcoat pocket, into which he jots down anything that strikes him, or any good thing that he hears said, or a reference he thinks will come in useful to him."

Samuel Butler, *The Way of All Flesh*

All writers make notes. So do most designers. So, for that matter, does almost everyone else I know. The notes here are published by Herman Miller because they touch on a topic the company and their customers are interested in. Still, they are just notes, and any opinions in them are those of the note-taker, not necessarily those of the company. There is space here for your own notes, illustrations, doodles, corrections, arguments, additions. If you'd like to share any of those, please write to me in care of: Attention

Herman Miller, Inc.
Zeeland, Michigan 49464

Ralph Caplan

A Designers are people who like to think with their hands and are understandably reluctant to give up that control, even though the computer can do it more efficiently. Milton Glaser, perhaps the most prolific sketcher I know, has a book in process [at the time of this interview] called *Drawing Is Thinking*, which is a collection of his drawings over the last fifty years. My friend Frank Wilson, the neurologist, wrote a book called *The Hand*. It's based on years of study and experience and interviews with people who work with their hands. It is devoted to the relationship between hand and mind.

Q+A/

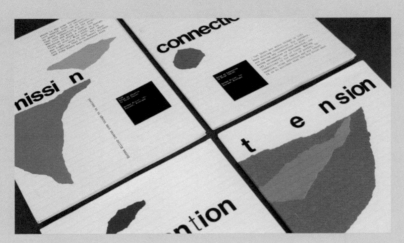

Notes on Attention

some incomplete thoughts
with room for improvement

by Ralph Caplan

Q Have you seen a difference over your long career in how designers and creative people work? I don't mean the use of computers, but how designers approach a project, how they nurture ideas and bring them to fruition. I'm thinking of how accelerated everyone's lives have become, coupled with the overwhelming amount of visual information we all have to process.

A More creative work today is done collaboratively. I suppose it always was, but now it is more forthrightly acknowledged. The principal differences, though, appear to be between individuals. There surely is a lot more hype than there ever was before along the lines of selling techniques for shortcuts designed to make up for lack of talent and business acumen. And it's not all hype. There are techniques that can be learned, and they do save some time. But I think the big changes probably can be traced, one way or another, to transformational technology. Still, we seem to need the old supports even when we don't. In light of the giant strides in telecommunication, I'm amazed at the proliferation of conferences, even though the subject matter and ideas could be, and probably have been, already disseminated by other means.

Notes on Attention
by Ralph Caplan.

Herman Miller, Inc.
Zeeland, Michigan

Herman Miller tries to pay attention

so that people are free to attend to what they care about. Ironically, though, the freest societies invariably create environments that militate against attention. Visual pollution is harmful not just because it is ugly but because it is distractive. And therefore destructive. Like other pollution, it destroys the balance of nature---in this case, human nature. A climate loaded with designs clamoring for your attention is a climate in which you end up paying attention to nothing. For example,

Random

"Designers have to yank the new technologies around, not be yanked around by the new technologies. I bet there were a lot of mindless circles when the compass was introduced."

Lance Wyman
interview with Armin Vit, *Creative Review*, June 2006

Masato Samata / Delaware

Tokyo, Japan

Left:
Take Off The Shoes,
cross stitch.

Right:
Surfer, designed on the
occasion of the Adidas
Diesel party held in Shanghai.

Delaware, formed by Masato Samata in 1993, is a self-described 'supersonic group' whose work includes poster design, writing, live musical performance, and cross-stitch. The artists at Delaware refer to themselves as 'artoonists'—a hybrid of artist and cartoonist. Working largely with bitmap patterns, they design directly on the computer—but in an iterative, sketch-like fashion.

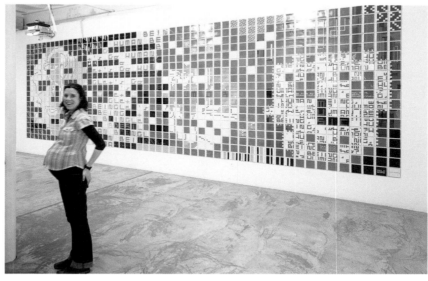

Top:
Venus De Corgi, Knit design
commissioned by Corgi
Hosiery Ltd., Wales.
for the Pitti Uomo exhibition,
Florence, Italy.

Right:
Let's Go! Human Being #3.
artwork for Delaware's solo
exhibition "Designin' In The
Rain," held at the Ras Gallery,
Barcelona.

Paul Fuog /
The Co-Op

Melbourne, Australia

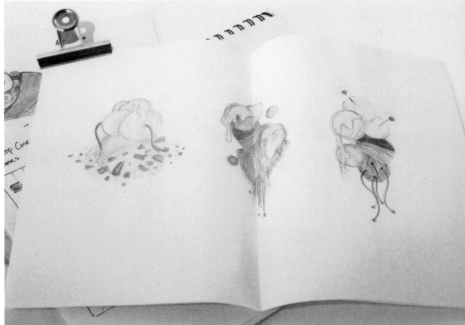

The Co-Op is a Melbourne-based design studio comprising Paul Fuog, Dan Honey, and Bec Worth. A small and fairly young outfit—it opened for business in late 2004—the Co-Op has quickly built an impressive portfolio of work for clients including Levis, Adidas, Polaroid, and the city of Melbourne.

THE CO-OP'S WEBSITE STATES, "For us, design is practiced, refined, and carefully applied," and this acknowledgement of trial, error, and hard work is readily apparent in their sketches—drawn, unusually, on a single roll of tracing paper.

"It often depends on what I am sketching as to what format I use," says Fuog. "But I do like to draw on tracing paper rolls when conceptualizing 3D or environmental works. Those sketches are generally quite quick and unrefined; often you need to sketch it from different angles or sketch varying components of the object, so it helps if you can see all the sketches together. Rather than having to turn the page, you can just keep on rolling it out. I picked this technique up

CELEBRATE ORIGINALITY

FROM TOP LEFT: THE SNEAKER RRP $160, LINEAR TEE RRP $60
KNIT PRESENTATION TRACK TOP RRP $150, RELENBAUER TRACK PANT RRP $100
ZEBRA NYLON RRP $120, LEADER SUEDE RRP $120, PREMIUM BASIC TEE RRP $40

adidas
ORIGINALS

"This was a hero brand image developed for print and motion applications. Adidas Originals is intrinsically linked with the concept of time. Their product is taken from the past and reinterpreted for the future. The brand is timeless but always evolving. The creative direction interpreted the idea of bending space and time. An intergalactic spinning product showcase was suspended entirely and photographed.

In this project, the sketches came together really easily. The drawings were set up in layers, and I built upon these until I was happy with the amount of action. Translating the sketches to the 3D product sculpture, though, was a total nightmare. Everything needed to be set up so precisely, and it took about eight hours to suspend everything. Perhaps I should have saved myself the pain and just rendered the drawing.

When I finish designing 3D and environmental pieces, they often look identical to the sketches. Therefore, I have learned to trust the sketches and ensure I get them right. I know that if it looks terrible on paper, it is going to look terrible in its true form.

Sketching is a very important part of the design process. It helps the exploration of good ideas and elimination of terrible ideas. The computer offers way too many possibilities and options. I like to limit these possibilities by setting a direction on paper first. Sketching allows me to visualize the possibilities so that once I hit the computer, things flow on and I experience fewer blockages. During the project, I will often move back and forth between both media. If things aren't going the way I want on the screen, I go back to the sketchbook. It is a great way to work through design problems."
—Paul Fuog

from a friend and it has been invaluable," he explains.

"I also sketch to plan out identity work, publications, and layouts. I think it is really important to go through this process. For me, sketching is a real timesaver. If I know what I'm going to do before I hit the computer, I just do it. Otherwise, I could end up moving things around on the screen until the end of time. When I do hit the computer, I still like to have a pen and paper handy. At this stage, I scribble on whatever is in front of me—old printouts, receipts I should have filed, other people's notebooks.

"I am always scribbling on something. Most of the time I'm unaware I'm doing it. It's only when I look back that I discover these ridiculous sketches. Some

are really disturbing. These don't get stored; they get destroyed before someone analyzes them and puts me behind bars. I'm not really sure those particular sketches have anything to do with process; I'd probably attribute that style of sketching to boredom."[11]

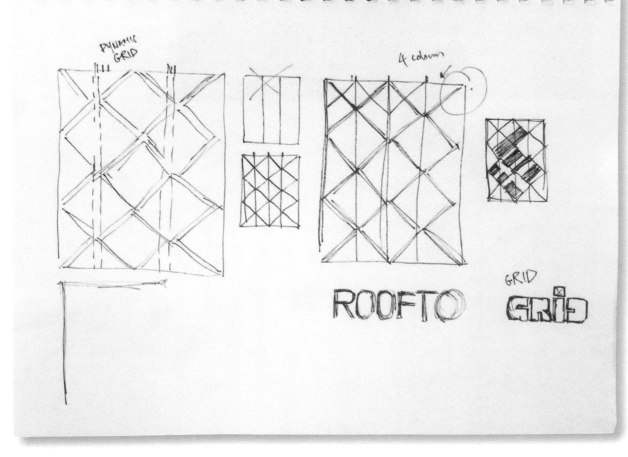

Rooftop Cinema
Collateral Design

"Rooftop Cinema recontextualizes cinema, creating an entirely new experience. Patrons sit up high, with grass beneath their feet, all the while enjoying a magical view of Melbourne city. As a result, we based the creative on the theme of 'new context.' A selection of popular films was explored and reimagined within Rooftop parameters. Iconic props from the films were constructed into unexpected 3D forms culminating in a series of Rooftop-esque posters that challenge the viewer's accepted perspective. In addition, we gave a further nod to general cinematic themes of drama and tension through the development of an angular grid system that allowed for dynamic typography and digital-inspired brand patterning.

The major challenge we had in this project is that we let our imaginations run a little too wild. We sketched out these elaborate 3D forms, which we loved. When we presented these to the industrial designers, they just laughed, as there was no way they could create our plans in the time frame or budget. So back to the drawing board we went.

Sketching was integral for the layouts. The grid was really challenging to work with, so we printed it on tracing paper and then worked and worked the type compositions with pencil and paper."

—Paul Fuog

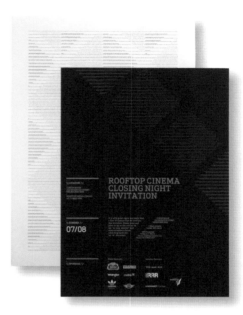

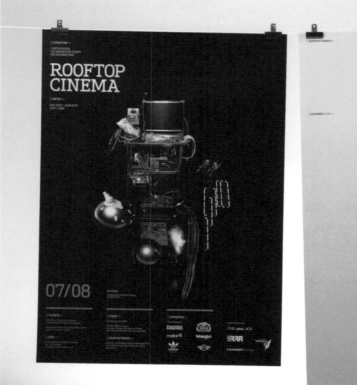

Morag Myerscough /
Studio Myerscough

London

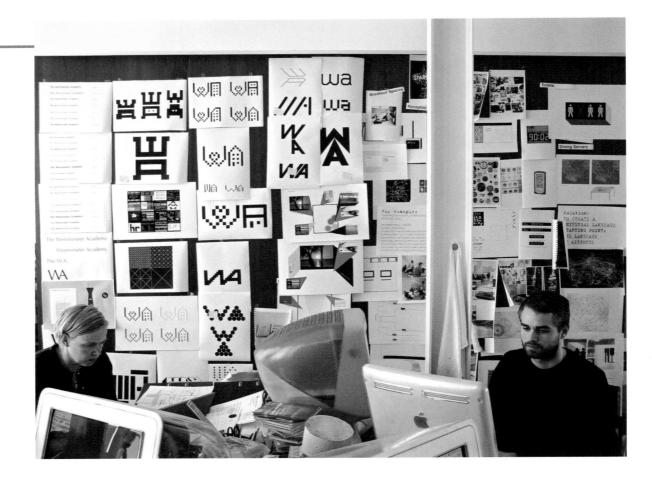

Studio Myerscough was established in 1993. Since then, the studio has worked with some of the most respected design-led companies in the United Kingdom, with projects including signage for The Barbican Centre, exhibition design for the Science Museum, and branding for Conran, Wedgwood, and the Tate Modern. In each project, the integration of design and its environment is central to founder Morag Myerscough's approach.

"When I was at St. Martin's and the Royal College of Art, I used sketchbooks all the time to keep notes for inspiration—they were my boxes of precious jewels. But that is a very safe place to be, and it was sometimes difficult to translate the energy in my sketchbook into reality. My aim over the years has been to keep that energy in the final outcome of my work— to keep it fresh throughout the whole process and not get lost along the way.

"More and more I found the need to put things on the walls around me, to live with them, hence the sketch walls. I like being surrounded by ideas and thoughts—containing these ideas in a sketchbook was too controlled. A glance at any moment at an image or

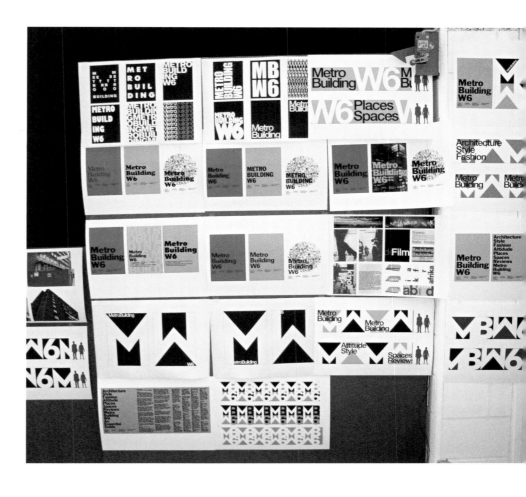

a piece of text can change my whole approach. I feel very strongly that I want my work to leave an impression on people, or cause them to feel an emotion, and so I need to feel those emotions, too.

"When I am working on a project, the sketch wall is up as long as it is at the concept stage. I use sketches for presentations, even though some people get confused or don't want to see them. I know that in this way I can get more valid responses for developing the work to the next stage.

"A photograph is taken of the wall as a record. Then I take the ideas down and a new wall begins for the next project. I work on so many diverse projects, from Wedgwood packaging to environmental graphics, that

I just do not have the brain capacity to store so much information.

"I do let some things hang around for longer—samples of type, ceramics, books, dresses, invites, postcards—just general bits and bobs that I like. They're all around me all the time, and I often go and get a Danish pot or a piece of glassware from my house as a reference, much as I would have put an image in a sketchbook in the past. Writing this, I realize that my whole house and studio (which is one big building and therefore accessible all the time) is a three-dimensional sketchbook, and I have to say it is fantastic being inside it and having the luxury of space to be surrounded."

Myerscough's studio walls act as a three-dimensional sketchbook, surrounding the designers with work in progress and random pieces of inspiration.

THE DEPTFORD PROJECT

"This is a regeneration project for the Deptford neighborhood in southeast London. It was a real labor of love. I hand-cut the stencils and hand-painted the whole train with my assistant Charlotte. Luke Morgan did the crazy Elvis toilet, and we made the table from reclaimed lab tables. I hand-stenciled all the stools, bought the plants from Columbia Road, and even planned out the disabled access. It was great fun."
—Morag Myerscough

Johnny Hardstaff

London

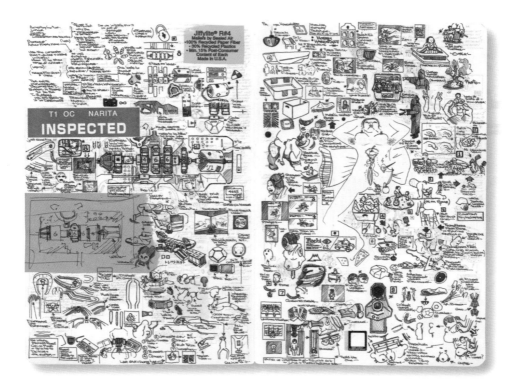

Initially a print designer, Johnny Hardstaff's spare-time experiments with moving images caught Sony PlayStation's attention. The resulting commission, the film _History of Gaming_, won Hardstaff immediate critical success and led to his signing to Ridley Scott Associates and Black Dog Films, where he has directed films for Radiohead, Orange, and the BBC, all while continuing to push his personal experimental projects.

HARDSTAFF'S SKETCHBOOKS ARE overwhelming. With dozens of ideas squeezed onto each page, to describe them as visually dense is a vast understatement. "They're an exact window on what I do and how I do it—even why I do it. When I was a child, my father would paint the detail on models for me with a one-hair sable brush. It's that level of attention to detail that I have grown to expect. Anything less, and I feel shortchanged." He points out, "I want to control everything," which has led to stockpiling his preferred pad and pens in case they are discontinued.

Certainly, this precision and focus is reflected in his film work, although Hardstaff points out that he rarely revisits his sketchbooks to mine ideas. "I download

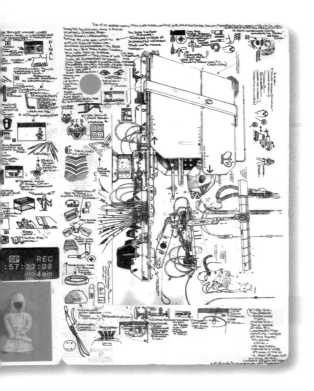

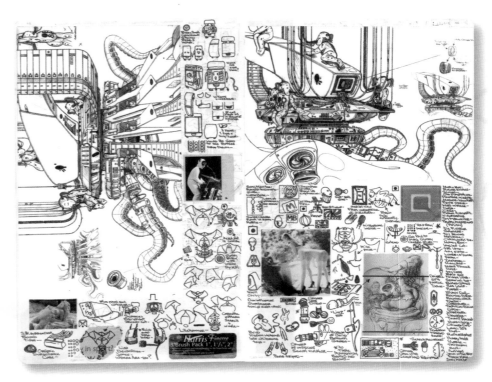

and move on. I used to go back to the sketches, to dissect and assimilate, but it's pointless. I don't need to, and I get nothing from them. The irony is I spend all this time recording thoughts and notions and then discard every entry. I'm very much a designer-director, and I respond to briefs—hopefully—in a different and original way each time. Therefore, old thoughts are exactly that: old and inappropriate."

In fact, he says, rather than having benefited his work, "they've probably detracted from it. But being able to draw has proved hugely beneficial. I work among some amazing designers and directors who can draw wonderfully. Ridley Scott. Jake Scott. I admire them, and I find the creative visions of those who can't draw to be inevitably lackluster.

"The conclusion is this: I keep these sketchbooks because they look nice. They're a project and an end in themselves. It's another way of being more productive."

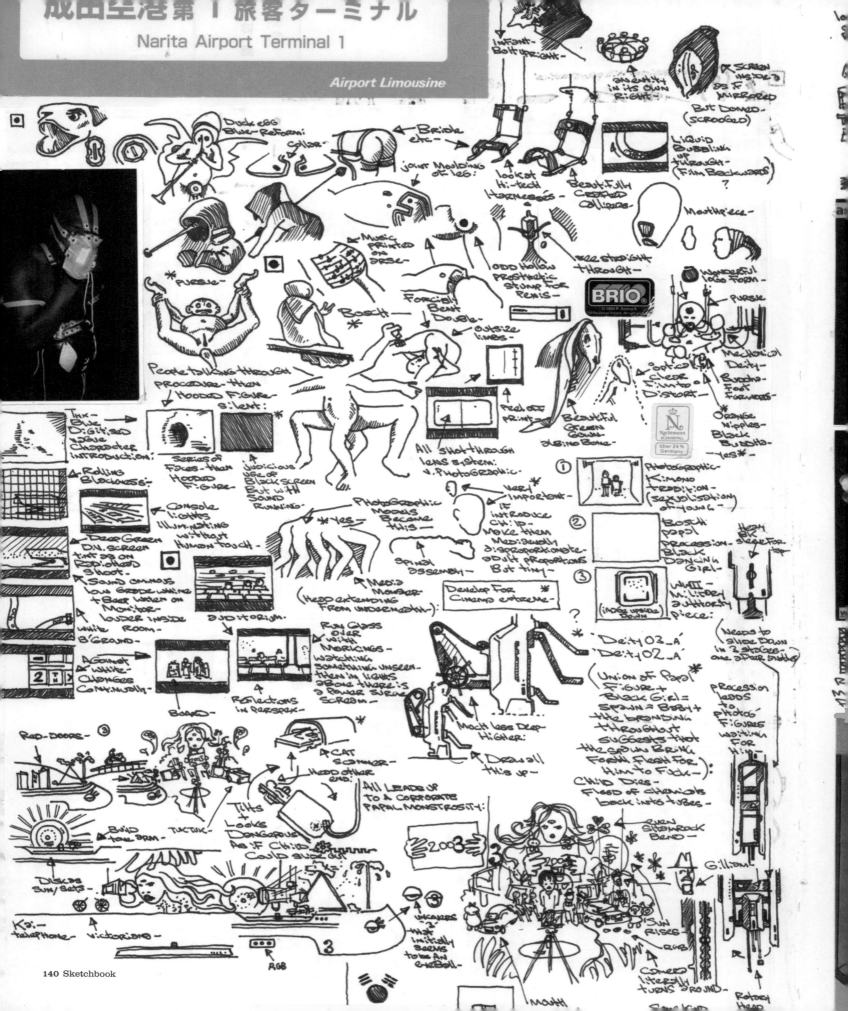

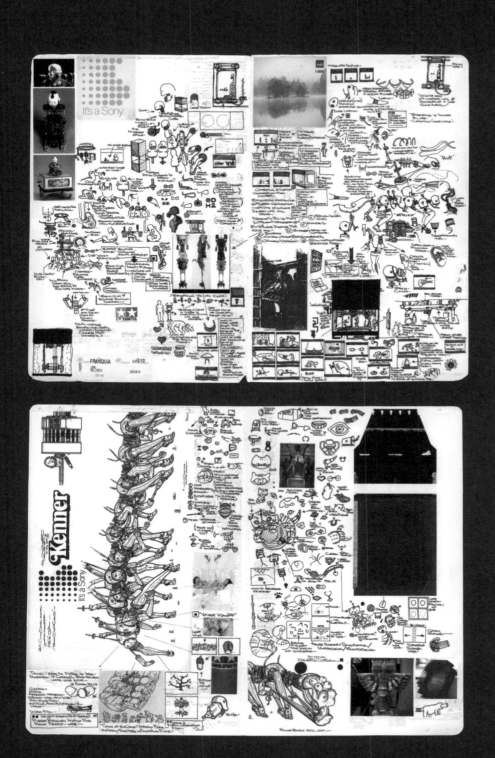

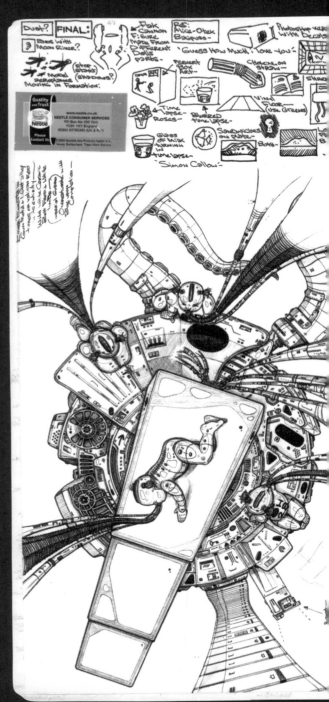

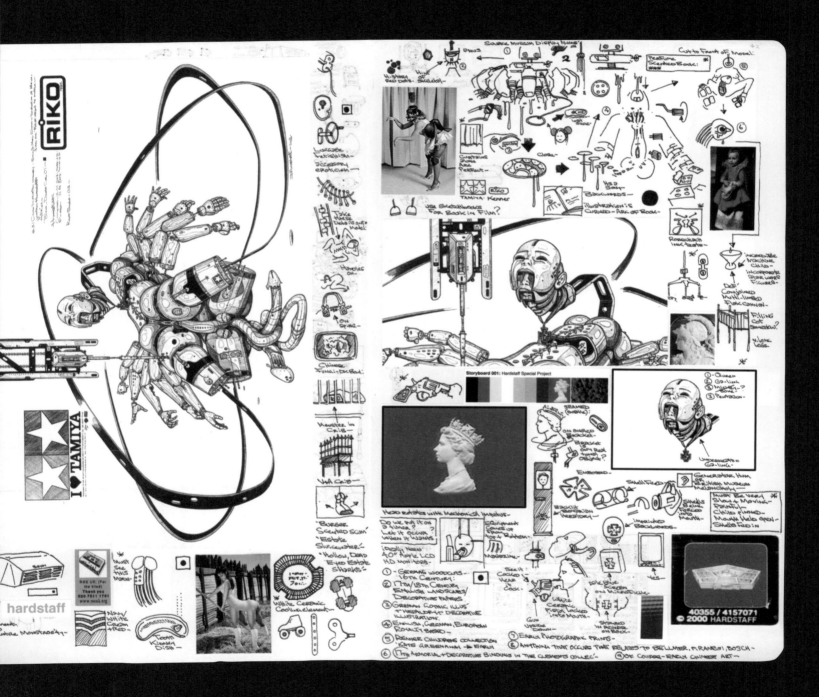

Catchers in the soul

Framespotting

Jonathan Romney

BACK in July, you may have seen the front page of this newspaper and wondered if April 1 had come late. If the news was true, you wanted to shudder and pass on to other less vertiginous thoughts. The story was that scientists working on a £20 million British Telecom research project called Soul Catcher 2025 were claiming that, 30 years from now, it would be possible to store entire human memories on "immortality chips". People would be able to record their memories on chips implanted in the body, then replay them to themselves, or others, on screen or direct to the brain. It was claimed that extraordinary possibilities are opened up, for teaching, for treatment of Alzheimer's, or — more disturbingly — for recording crimes as they're perpetrated: a kind of in-brain surveillance. Trust Telecom, though, to express the revolution in the most mundanely British way: "With these chips, we wouldn't have to rely on holiday snaps."

What's uncanny about Soul Catcher is not just that — to use the clichéd response to technological innovation — it's "like science fiction", but that it's straight out of a specific strain of recent sci-fi. William Gibson's novels and Kathryn Bigelow's much-maligned film Strange Days — recently released on video — both posit "movies" decanted right to the cerebral cortex. From his 1984 book Neuromancer to the newly-published Idoru, Gibson imagines a world in which reality is not so much virtual as vicarious. In his future, cinema is replaced by "simstims" — pre-recorded experiences you plug directly into your head, allowing you to become the protagonist. Simstims have their own "stars" — people paid to act out glamorous situations and record them through lenses implanted in their eyes. The scenario of Strange Days is simpler, and closer to the "reality programming" already

challenging, because closer to home: in Strange Days, people get a kick not from fantasy but from direct unmediated reality. They can live out other people's sexual experiences or violent crimes, or relive their own memories. The film's hero, SQUID-trafficker Lenny, is addicted to reliving highlights of his lost romance.

But this direct retrieval also entails an irreparable distance from the texture of memory. What's lost, as Lenny constantly replays his favourite hot tryst, is the sense of how that memory has transformed his life since — how it might have germinated in his brain, formed links with other memories, become part of his language. Instead, it's fixed, fetishised, looped into an obsessive ritual. SQUIDS or Soul Catchers offer memories on a plate, but not the fluidity of memory or its capacity for transformation. They divorce memory from the medium that it's intricably woven into: language, which has the dynamic capacity to transform memory even while recording it in speech or writing. But we should defer to Dr Chris Winter of the Soul Catcher team: "Speech and writing are such crude forms of communication."

Soul Catcher is already scary enough in the assault it threatens on private mental space, which is even now under siege. Imagine all the people feverishly documenting their lives on camcorder for public consumption — as video diaries, Beadle-bites, or home-made porn — doing the same direct from the brain, putting their subjectivity on the market.

But there's also the question of who owns the technology and the right to use it. Will everyone get to tape their lives, or only a selected few? Will a life be considered worth living if it's not recorded? Will the chip be reserved for documentary purposes, or will it become entertainment, and simstim stars hired to live to order, for our delectation? Will only waking hours count, or will dreams be considered fair game?

Will everyone get to tape their lives? Will a life be considered worth living if it's not recorded?

Then there's the problem of how other people's brain signals can be unscrambled and made readable. Even if you can turn a rush of perceptions into a coherent 3D picture — and the disorienting scrabble of sound and movement that begins Strange Days suggests that's not so easy — how then could you read a moment of someone else's life outside the context of the whole? What meaning would a day trip into someone's head possibly have? How do you decide what constitutes an event in someone's life? Proust knew that the key moments in an existence weren't necessarily the tangible events, but were more likely to be found in the "downtime" spent sniffing bushes or drinking tea — all the stuff you'd probably fast-forward if you were using Soul Catcher technology.

I wait to be persuaded (or, more

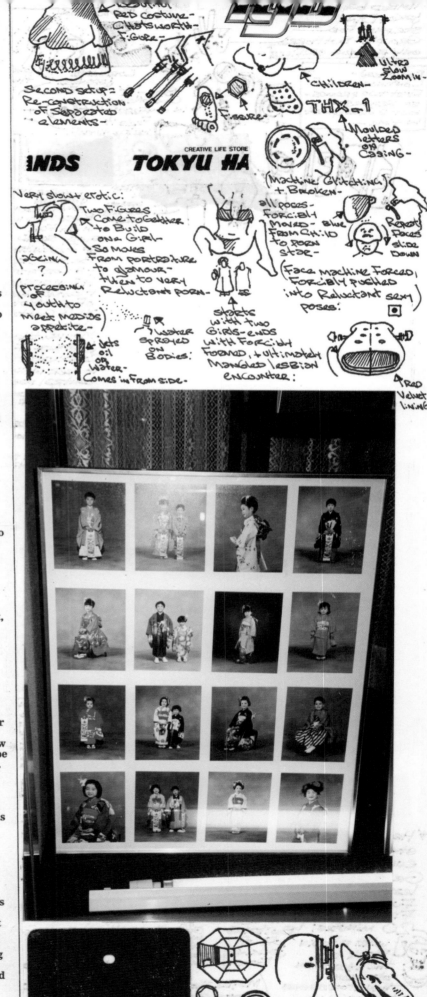

Frank W. Ockenfels 3
and Frederick Green

Los Angeles

Frederick Green

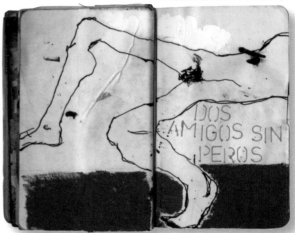

Close friends and sometime collaborators, Frederick Green and Frank W. Ockenfels 3 often get together over the weekend and spend a day hanging out, talking, and working in their sketchbooks. The obvious point of connection for them is photography—Ockenfels is a highly regarded celebrity photographer, and Green, who is in charge of print advertising for Focus Features, has an abiding passion for vintage and pinhole cameras. But neither is content to express himself through a single medium, and for both, sketching offers an essential outlet for boundless creativity.

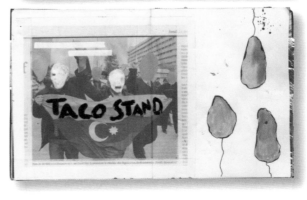

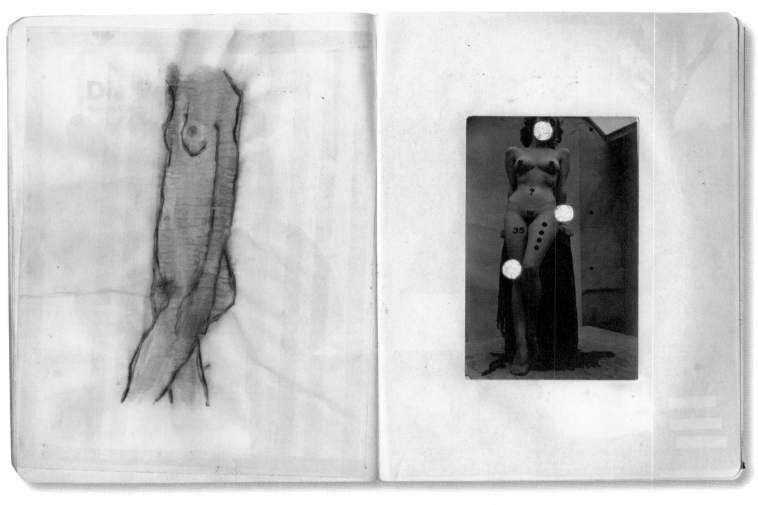

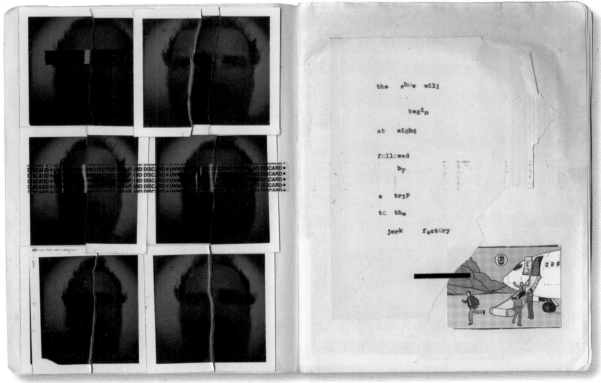

the sHoW will

begin

at eight

followed

by

a triP

to the

jerk factOry

اعتقال مديري
مصرفين بإيران
طهران(و.م.ع): أعلن الأربعاء

على ما اقترفت يداه في حق
سلام معيل الأسرة الوحيد
لم تفض التحريات إلى إيقاف
م وقف لغز الجريمة وتعددت
ضات والتأويلات وبدأ اليأس
نفوس أفراد أسرة الضحية
وكل مهمة البحث وإعادة

خلال آق
واقتصاد
مؤيدين
سياسية
لكن ف
الدين ف
بين الن
فكيف

"My sketchbooks started out as tech journals, reminding myself of exposures and lighting setups. Then on airplanes I'd start doodling over them. On a band shoot we'd be shooting Polaroids, tearing them up and taping them back together, along with the musicians, right on the sidewalk, in the moment. After a while I began doing a lot of collaging. I saw the journals as a place to remind myself what I'd missed out on during a shoot, a place for notes on how much I enjoyed or didn't enjoy the shoot. Sometimes it was just a rant, but sometimes you realized after the shoot that you took a certain photograph to express something that you're going through in your life."
—Frank W. Ockenfels 3

"This was a fashion journal I did for *Rebel* magazine in France. They sent me three pieces of clothing, none of which matched. I had a great time running around the woods by my house in upstate New York with this Czech model. Afterwards I collaged everything and brought it back to her, and she etched over the prints; scratching the word red in Czech into the print, so we were collaborating on the piece. I think people miss the point; they think they need to be the only one to do things, and the crew and even the models often don't feel part of the process."
—Frank W. Ockenfels 3

"When you put a camera in front of your face, you sort of break the connection between yourself and the subject, so often photographers shoot using an empty camera for a while, just to break down the wall and get the subject comfortable with the camera. It's harder to keep that connection when everyone is huddled around a monitor.

I'm really frustrated by where photography's gone. It's all on the screen: You don't load film in the camera, you don't get a print back, you don't hold the contact sheets, you don't circle the selects

I was on a movie poster shoot in London recently. Although I still use film when I can, all movie poster and advertising work is done digitally nowadays. So I'm packing up at the end of the shoot, and by the time we got the lights away, the images had been uploaded to a server, and people in Los Angeles were looking at them—I hadn't even looked at them yet.

I was visiting a digital retouching studio, and the work area smelled so clean. My nose used to burn from the fixer after being in the darkroom—you really felt like something was happening. That's where the journals come in. I can get my hands dirty again, and I can feel the edges of the paper."

—Frank W. Ockenfels 3

"This was for a mainstream magazine, *FHM*, so even though the subject was porn actress Jenna Jameson, you couldn't show that much. We live in this puritanical society and yet there's so much sexual content in the media. The more upset they get about it, the more I want to push it. This other girl was lying there, so I said to Jenna, 'Go over to her and pull her pants down as if you're going to go down on her,' and the editor's going, 'No, no, no, you can't do that!' The girl was totally aroused by the whole thing. You can see her squirming on the contact sheets."

—Frank W. Ockenfels 3

"When you're photographing Jack Black, it's just like, 'Stand back!' The shoot was out of control, but the magazine made it so tame, they just missed all the energy. Everything has become so calculated and overly re-touched; having that moment with your subject has gotten harder. In my frustration I ended up tearing up prints and slapping them down to try and recapture that energy It's actually become one of my more recognizable pieces of late."
—Frank W. Ockenfels 3

Mar Hernández/ Malota Projects

Valencia, Spain

Mar Hernández, otherwise known as Malota, is a Spanish designer and illustrator. Her work, which ranges from restaurant identities to designer plush toys, has been widely exhibited, most recently at a solo show at El Círculo de Bellas Artes in Madrid.

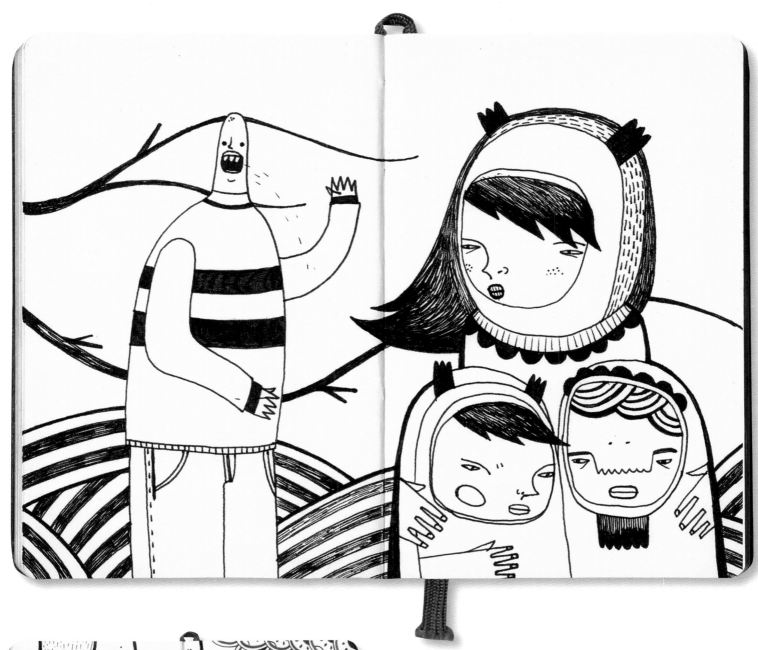

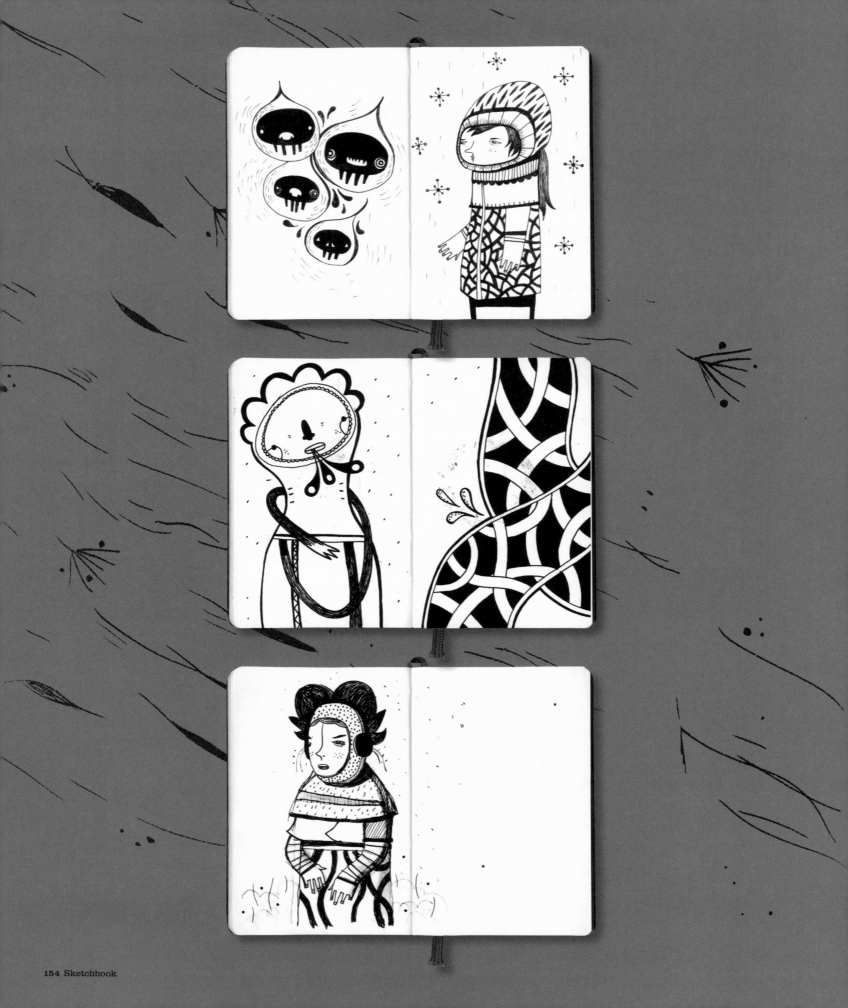

"I always bring my pocket Moleskine with me; I sketch everywhere: while having a coffee, sitting on a park bench, or waiting for the bus.

 These sketches are not for any specific project. I think it's interesting to work without a brief occasionally because you feel free to draw anything. Sometimes you come up with things you wouldn't have under the pressure of a brief. When sketching, everything is more natural and less forced."
 —Mar Hernández

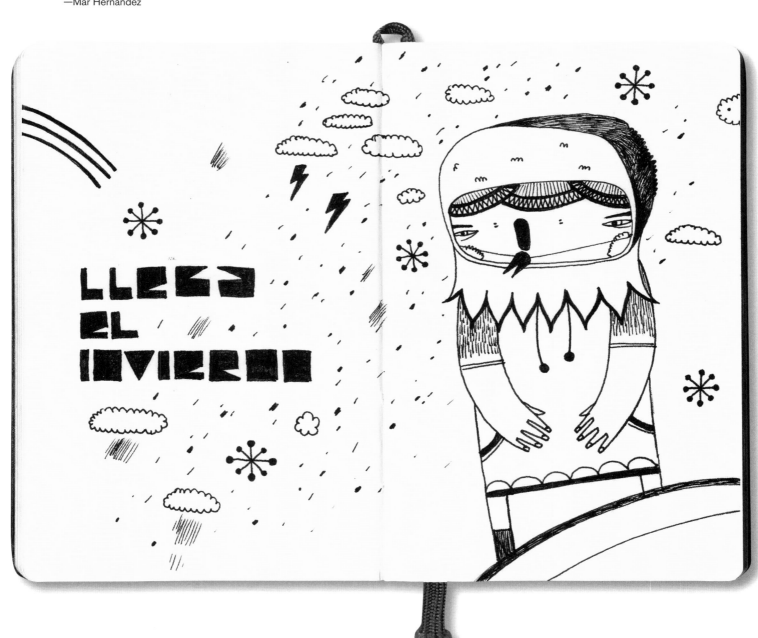

Stephen Doyle /
Doyle Partners

New York

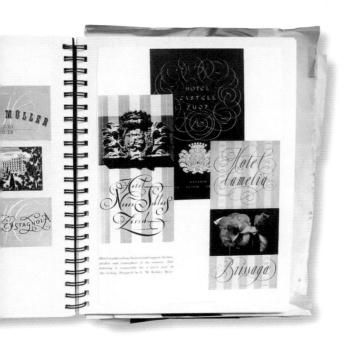

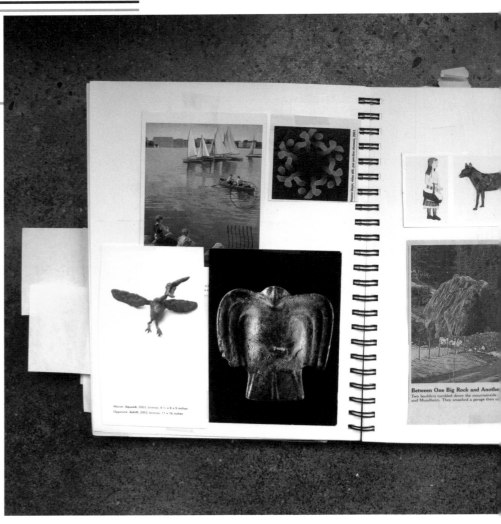

Stephen Doyle is principal and creative director at Doyle Partners, a New York-based design studio renowned for its thought-provoking mix of functional design and wit for clients including Martha Stewart, Barnes & Noble, and global real estate firm Tishman Speyer.

MY INTRODUCTION TO Stephen Doyle's scrapbooks came during a cocktail party in his studio (wine glass in one hand, scrapbook in the other, it was easily the most congenial interview conducted for this book). Examples of the firm's work hung on the walls—CDs, film titles, installations, global brands. The breadth of projects is evidence of Doyle's varied interests and curiosity.

While I flipped through his books, Doyle chatted easily to guests on topics including experiential buildings, country singer Randy Travis, and a sculpture he's working on, gluing human hair into a book called Manly Pursuits. Further proof of his restless mind, if one needed any, came from the scrapbooks themselves. Newspaper articles, Chinese cigarette packaging, a

letter from former New York governor George Pataki, photographs, invitations, and a drawing captioned 'A bird that I saw as I remember seeing him, Dec 27, 2006, Finca Rosa Blanca' are just a few of the items that jostle for space on the pages of his books. "There's a lot of stuff you don't want to lose. I just tape the shit in there," he says. "If I were to get arty about it, I'd never do it. The books themselves are not a project, but they fuel my ideas."

Though the sketchbooks rarely apply to Doyle's design projects, he does turn to them for inspiration: "I use them as snack food. I feed off of them, visually. Often, I'll go through them if I'm trying to create something artful and distinctive. Much of what I save

are images from art magazines dealing with material, color, or scale."

Ironically, he doesn't often look within his own field for stimulation. "I'm not such a graphic design guy; I might look at antique packaging or old book jackets … or if I see an interesting or inventive graphic while traveling or biking around New York, I'll photograph it and paste it in a book, but otherwise, in terms of looking at graphic design for inspiration, who gives a shit? I don't want my stuff to look like Paula Scher's or Stefan Sagmeister's or Michael Bierut's. Besides, how much good graphic design is really out there, anyway? As Paula once said, 'The level of mediocrity in design has really risen quite high.' A lot of the design I see

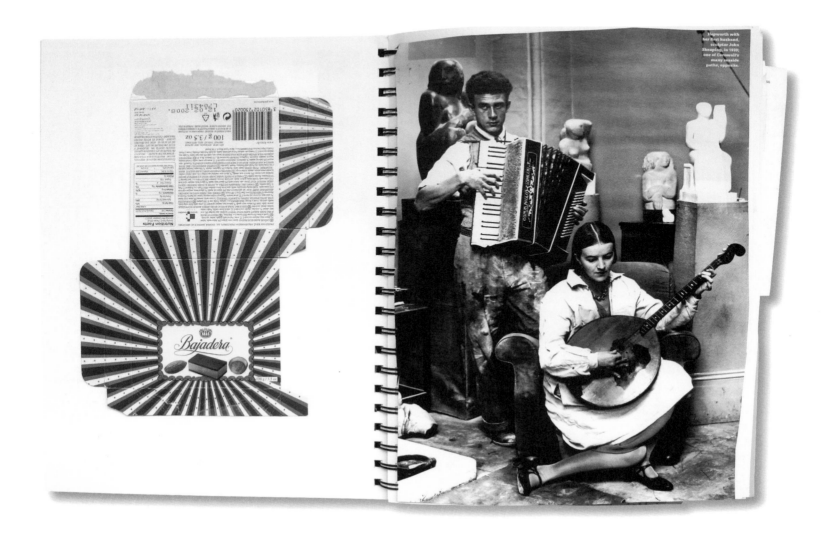

Hepworth with her first husband, sculptor John Skeaping, in 1920; one of Cornwall's many seaside paths, opposite.

looks like good design, smells like good design, but ultimately it's just packaging—there's no interesting narrative there. For me, it comes down to what kind of messages am I interested in communicating? It's never about the graphics."

In addition to his scrapbooks, Doyle has watercolor books that he and his wife and children share on their vacations. These are doubly envy-inducing; not only have they visited some breathtaking places—Amalfi, St. Petersburg, Provence—but the Doyle family all are dab hands with a watercolor brush as well. Right after this interview, they're off to Iceland, which Doyle is keenly looking forward to. "There aren't a lot of people there, which is great, because I'm no good at hands or feet."

Stephen Doyle's scrapbooks are packed with magazine clippings, foreign packaging, and other inspirational ephemera.

October 2006

Though the examples shown here are Doyle's, his wife and children also use these books while on vacation to capture the landscape in watercolor.

a bird that I saw
as I remember seeing him
Dec 27 1996
at Finca Rosa Blanca

Mirko Ilić /
Mirko Ilić Corp.

New York

In January 2008, the HAOS gallery in Belgrade hosted an exhibition of drawings by designer and illustrator Mirko Ilić. Around 600 of his sketches were displayed along with the finished works, offering attendees a unique insight into Ilić's creative process.

What made the exhibition unusual was that the original drawings were not just hung on the walls but also placed on the floor. Visitors walked on top of them, resulting in the complete destruction of the works by the end of the exhibition, underscoring Ilić's belief that his sketches are unimportant—it's the finished piece that matters.

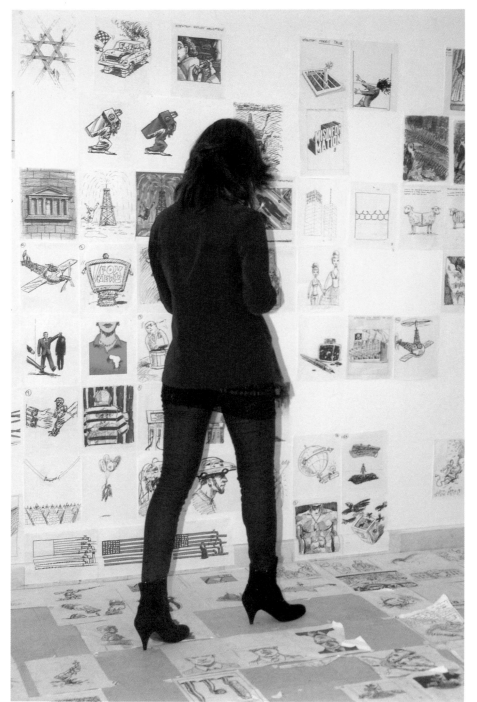

Lance Wyman /
Lance Wyman, Ltd.

New York

Lance Wyman specializes in branding and wayfinding systems for public environments and is credited with helping define the field of environmental graphics. His graphic system for the 1968 Olympic games in Mexico is cited as "one of the most successful in the evolution of visual identification."[12] Other successful projects include branding and signage systems for the Minnesota Zoo, the cities of Detroit, Hoboken, and Albuquerque, and the LG Arts Center in Seoul, South Korea.

"I HAVE ALWAYS SKETCHED," says Wyman. "Sometimes I use an empty space in the morning paper (if I can find one). Sometimes it's on a lunchtime napkin or on a piece of the paper table cover. Sketching is a way of capturing an idea before it flits away, and a quick check to see if an idea has visual potential.

"Prior to the computer, I would take the sketching process on a refined path to a final solution. Now I rely more on the computer to do that.

"Sometimes the computer comes first. If a moment of inspiration occurs while I am on the computer, I'll go straight to a drawing program, or I'll go online for research, and get on with it. I find that sketches factor in more during the times I'm not on the computer.

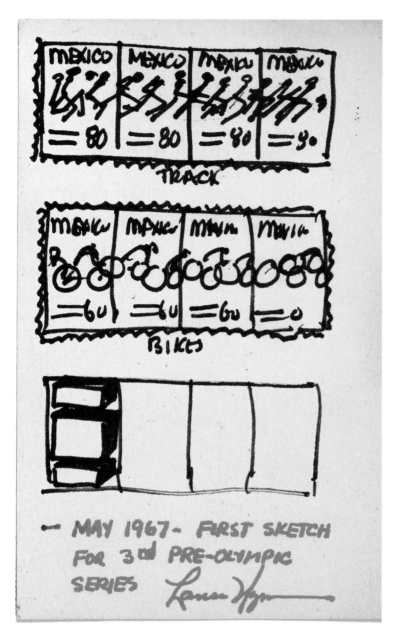

The benefit from sketching or from working on the computer can be the same. One lesson I've carried over to the computer is to keep a linear process intact. It is so easy, on the computer, to work over something and lose what I've started with. I try to remember to save the steps as I go."

'68 Olympics
Identity/Wayfinding

Comite Organizador de los
Juegos de la XIX Olimpiada

"Sketches were an important first step when I designed the postage stamps that represented the 19 sporting events for the 1968 Olympic games in Mexico. The idea of running silhouettes of athletes in motion through one stamp into an identical stamp was first visualized as rough sketches of runners and cyclists.

When designing the logotype, I went pretty quickly to pure geometry once I realized the Olympic five rings could integrate with and influence the 68 number forms. It was like sketching with a compass."
—Lance Wyman

National Zoo
Identity/Wayfinding

"The sketch wall is a good way to keep in touch with the process of designing each individual symbol, and when designing a system of symbols, it keeps me in touch with how the different symbols relate to each other.

Prior to the computer, the walls were kept up throughout the development of a project. They became part of slide presentations and were often taken to conference room meetings. Each vertical strip of sketches is hung by two pieces of tape at the top so it can be easily taken down, folded up like an accordian, and rehung, one strip next to the other.

The wall constantly changed to tell the story of the project development. I still use a similar method, but on my computer screen and printed out when I need it."

—Lance Wyman

Design: Wyman & Cannan, Ltd.
(Lance Wyman, Bill Cannan, Brian Flahive, Tucker Viemeister, Ernesto Lehfeld)

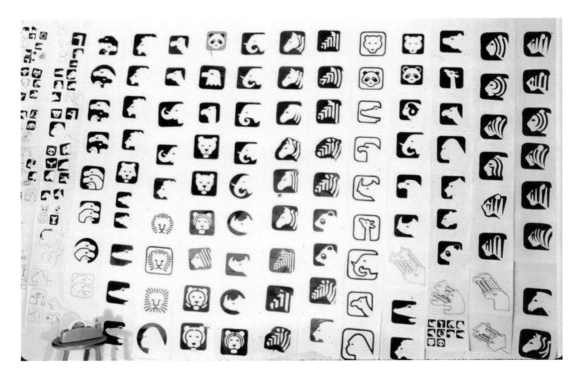

Minnesota Zoo
Identity/Wayfinding

"Sketching was very much
a part of the Minnesota Zoo
logo design. It helped explore
the synthesis of an *M* and
an animal."
—Lance Wyman

Design: Lance Wyman, Ltd.
(Lance Wyman, Stephen Schlott)

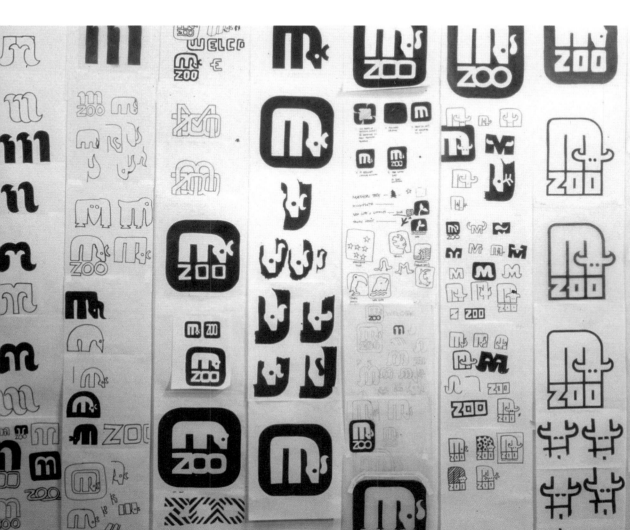

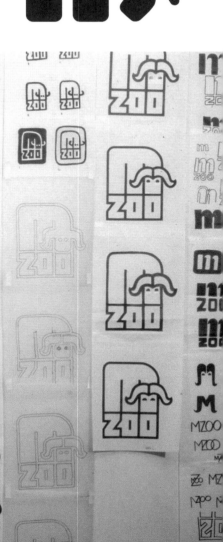

Jamie Delaney

Dublin, Ireland

Graphic designer/art director Jamie Delaney recently returned to his native Ireland after working in London and later studying at London College of Communication. Though relatively new to the profession, his print and Web work shows a clarity and attention to typographic crafting that, according to prolific sketcher Delaney, often has its origin in notebooks.

New Italian Goddess

**Come to Cloud 9 /
Very Discreet /
Offers Body to Body
Massage Including
A&O / Open 24
Hours / Hotel
and Home
Visits**

07903
961
946

New In Town

Young and Beautiful

24/7

Open 24/7

All Services

No Rush!

Satisfaction Guaranteed

Come to Cloud 9 /
Very Discreet /
Offers Body Including
A&O / Open 24
Hotel and
Home Visits

new
ital
ian
god
dess

07903
961
946

0771 659 1112

New Italian
Goddess

Come to Cloud 9 / Very
Discreet / Offers Body
to Body Massage
Including A&O / Open
24 Hours / Hotel and
Home Visits

07903
961946

New
Brunette
Model

All Services
Early/in Late
Spanking
Caning
Water Sports
Toys
Uniforms
No Rush
Massage
Hotel Visits

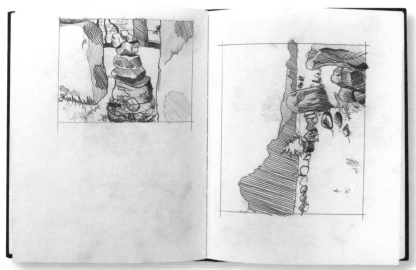

"This started as my final project for my M.A. course, and I'm currently presenting it to the Irish Heritage Board, who are interested in implementing it into their visitor's services. I spent six months researching ancient monuments such as stone circles, cairns, and burial tombs, and collecting and collating the local myths and folklore concerning these sites. I also spent some time looking into the possible purposes and reasons these magical structures were built. The aim of this research was to develop an information pack that would work in conjunction with the existing Ordinance Survey maps, to outline and better document the Stone Age and Iron Age monuments scattered over the British Isles. This package is for professionals in the creative industries, people with an interest in lifestyle, heritage, and learning in a creative way. This might be offered as part of the activities during a weekend away in the country, an interesting activity to take part in while enjoying the outdoors, or on a picnic. I wanted to give people a reason to explore their ancient heritage, enabling them to appreciate and develop a curiosity for these sights, which seem to have slipped out of our national consciousness and into the staid world of academic journals.

In researching the depiction of these sites in literature I was pleased to find that this subject was not confined to the text-heavy world of academia or archaeological manuscripts but also appeared in literature

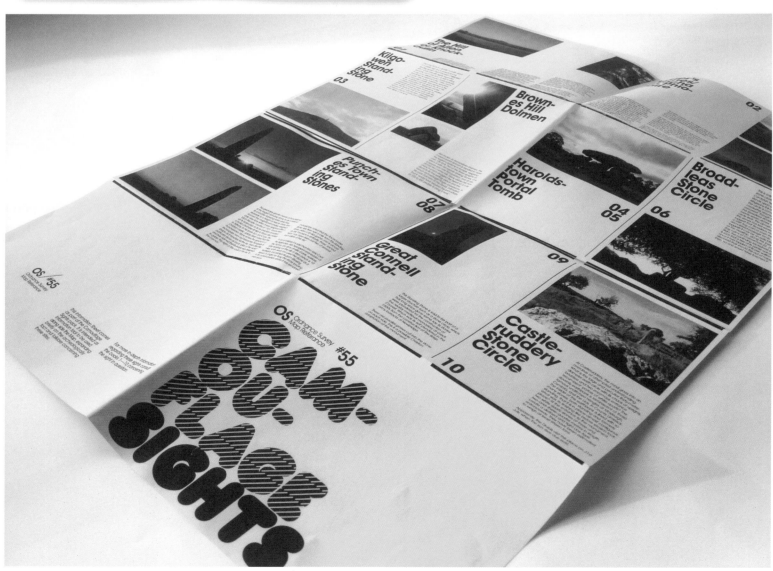

of a more imaginative nature. There seems to me to be two schools of thought on the matter: One is the elbow-patch-wearing academia school; the other is the mushroom-taking, dancing-around-stone-circles-under-a-full-moon school. Excuse this tongue-in-cheek generalization, but I feel it illustrates the opinion of the average 20- to 40-year-old. It is this demographic I want to attract to give them an appreciation for these nearly forgotten monuments. I want to offer a middle ground, giving people the facts alongside the myth and legend, and showing the sites to be interesting, educational—perhaps even magical—places to visit.

My sketchbook was integral to this project. I sketched the monuments, and it was such a long project I also used the sketchbook to file ideas as they came to me so I was able to look back over them when it came to constructing the final solution."

—Jamie Delaney

Joris Maltha and Daniel Gross / Catalogtree

Arnhem, The Netherlands

Catalogtree, a multidisciplinary design studio run by Joris Maltha and Daniel Gross in Arnhem, The Netherlands, takes their name from a technical term for filing structures—a perfect fit for their system-based approach to visualizing complex data. Their work has appeared in *I.D.* magazine, *idea* magazine, and the book *Area 2*, among others.

"We design by talking. With complicated projects we use our chalkboard as a tool during our discussions to quickly sketch the outlines of a project.

When we were commissioned to create a graph exposing family ties between employees in Knox County, Tennessee, we were given some newspaper articles and transcriptions of county commission meetings. From this material, we had to determine who nominated who to be on the commission, who was working for or had family working for the mayor's office or the sheriff's office or both.

We actually figured out we were looking for this while drawing this tangled web of nepotism on the board. We took pictures of most steps in the process to be able to return to previous versions."

—Joris Maltha

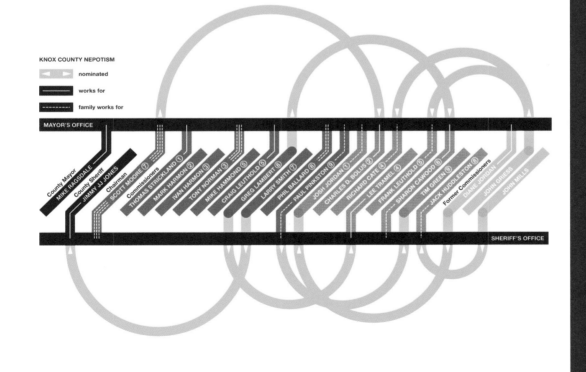

KNOX COUNTY NEPOTISM

◄ ► nominated

—— works for

----- family works for

"We often see the rapidity with which a task needs to be completed as a good thing, and I'm not at all sure that that's the case."

Frank Wilson is a neurologist who has been an internationally respected authority on the neurological basis of skilled hand use for over two decades. He is the author of the Pulitzer Prize–nominated *The Hand: How Its Use Shapes the Brain, Language, and Human Culture*. Now retired from clinical and teaching positions at the University of California, San Francisco, and at Stanford University School of Medicine, he writes, lectures, and consults on a range of issues concerning the relationship of hand use to human cognitive and artistic development.

Q+A/ Frank R. Wilson, M.D./ neurologist; author, *The Hand*
Portland, Oregon

Q In *The Hand*, you describe showing a film of formerly virtuosic musicians struggling to play their instruments to a group of similarly afflicted musicians, and your shock as you witnessed many of them fainting. What is the neurological basis for these physical repercussions brought on, at least partially, by emotional turmoil?

A That's a really interesting area, and one that I've been looking at a lot lately. V.S. Ramachandran touches on this topic in his book *A Brief Tour of Human Consciousness*. It's a very, very big subject right now. When you get into how the human body and brain work, you quickly become humbled by the complexity of this stuff, and how the nervous and neuromuscular systems and thought and emotion are profoundly interrelated and interdependent. The more interesting question to me is, why is it that working with the hand creates all these emotional dependencies? People who really think about themselves physically, and really use and train their body, have something else that has been activated, or, to use the jargon of psychologists, "unpacked." When we pay attention to what the body is doing and monitor it closely, we get into a domain of Zen thought and it all starts getting ineffable. But I think it's absolutely real.

Artists, dancers, and musicians sort of get lost in time as they use their body to create something, and when that happens I think they are simply experiencing one of the many consciousness potentials we have. So it may be the thing about the hand that is so specific to the creative process is that, although we really do have an extraordinary amount of control over the hand, it takes a lot of time. While that might be seen as a disadvantage in an efficiency-obsessed world, the fact that it takes so much time means everything else has to be excluded from consciousness. This is why sketching works, because it's a meditative process in which the nervous system is using the body as a way of re-experiencing relationships in the world.

Q I know you're concerned about the education system, and the frenzy to bring computers into schools, and its attendant decrease in the teaching of hand-based skills.

A I was at the Haystack Mountain School of Craft in Maine, and met an older couple who both taught at Harvard in the architectural school. The woman was talking about all the young architects who come and work for them, who are all trained to produce drawings on CAD systems. She said—and I'm not making this up—when they finished a drawing she needed to trace over every line with a pencil, because neither she nor the students had any idea if it'd work or not, and it's only if you go over everything by hand that you see if the machine has invented something that isn't real. There's something profoundly important about that.

Q When I see student work, it's often hard to peel back that outer shell and see past the level

of finish to get to the thinking behind it. And in my own work, increasingly tight deadlines often don't allow me to properly ingest the information and I'm tempted to move straight into the final execution.

A The element of time is really critical. It's an issue we don't think about seriously. We often see the rapidity with which a task needs to be completed as a good thing, and I'm not at all sure that that's the case. In a certain sense, the body, responding to impulse and intention, acts as a governor on thinking. It links it to the physical word. Milton Glaser and I gave a talk together a few years ago, and he spoke about this very issue. He said, you have this idea, and then you have the finished product, and in between the two is this messy space. And he said, "The computer makes that messy space go away, but I don't think that's a good idea."

Q I have a terrible memory for names and often use that trick of repeating a person's name immediately after being introduced. *The Hand* referred to the Russian psychologist Vygotsky's belief that "experience with the body establishes meaning or intellectual understanding." Why does using the muscles in your hands to draw allow you a greater degree of investment in what you're working on?

A For me, it's still a very unsettled question about these devices that operate and create a second interface between simple objects that used to be manipulated in the hand and the hand itself. A modern example of that is the robotic surgical device. There are certain kinds of microsurgery—say, reattaching a finger to a baby's hand under a microscope—that

even a surgeon with a very steady hand is almost completely defeated by. But a hand tremor can be eliminated if you use a robotic device that damps the tremor out, and now with minimally invasive surgery using endoscopic techniques they've got robotic systems doing coronary artery bypass surgery.

A few years ago, I met with a group of cardiologists who do this kind of surgery. They all agreed it's a lot faster, there's much more mobility, and the results are great—but the surgeons miss putting their hand on the beating heart.

Q On a similar note, my friend and old employer, Vaughan Oliver, has waxed nostalgic about placing a piece of type with the tip of a scalpel and about missing "having physically done a day's work at the end of the day."[13]

A It's probably an experiential and generational thing. I used to work with textile workers in San Francisco, some of whom were from the generation trained to work with real materials and who were then retrained to work on CAD systems. The computer could now design patterns on particular materials, and they never had to feel what it was like, they never had to touch the stuff, and as a result they felt disassociated from what they were doing.

The more significant problem was that other people could more easily interfere with them; a marketing person could now come in and say, "Why don't you use more red?" At some point they crossed a line where they realized they were no longer designers, they were computer operators using design software. And when they crossed that line, the whole thing dried up for them. I was involved in treating them for injuries that wouldn't go away, and it became appar-

ent to me that the problem wasn't that they had thoracic outlet syndrome or an ulnar neuropathy or carpal tunnel syndrome—their problem was that the job sucked.

You have to be very careful about saying "Aha, this is what went wrong, you should never use CAD systems," but there are complexities in how these traditional ways of doing things established themselves, and we are often blind to the history of how people decided this was a good way of doing it. Some of that comes back to bite us when we find a machine that will do it another way.

Q In his *Five Essays on Design*, Christopher Rose said, "The hand concentrates for you" while you manage the majority of sensory input to the body subconsciously.

A It takes time to sum up the implications, and that's part of what's going on. When you work on things manually, it happens at a pace that allows summing up, and the movement itself is evocative. There is something about doodling in which you are making small gestures that are indicative of something that's going on in a different way as you're thinking about something; you're sort of trying out possibilities.

A year after *The Hand* was published, I was invited by Woodie Flowers, a professor of mechanical engineering at MIT, to give a seminar. He said that one of the problems they were having was that a lot of the students they have coming in who have been raised on computers have problems with certain aspects of problem solving. For example, they'd give engineering students a problem from ordinary classical physics, along the lines of "If a

30 kg man walked up a 10-degree hill, how many calories would he expend?" Apparently you can't get into MIT if you can't solve that problem. They found that if they gave these kids four numbers and said "What's the answer?" the kids were all over the map. They're good at picking which formula is going to give them the answer, but they have no in-the-body sense of how much energy is going to be required, there's no out-in-the-world sense of it being harder to cut down a tree than a fencepost, no real-life experiential references on which they can draw in order to guess at the answer. They're *lousy* at guessing! And they called this an estimating problem. The way they now teach them to estimate is they give them hammers, saws, nuts, and bolts and have them build things.

I've been told they do something similar at the University of Colorado School of Engineering; they give remedial classes to all the freshman students. They send them out to Habitat for Humanity so they can figure out why things hold together and stand up and don't fall down, because they've never had the experience of doing any of that.

Q On some level, you might learn more about construction from building a house of cards then you would from designing a massive building on a CAD system.

A You certainly learn something by physically doing it, though nobody really knows what that something is. You learn some rules about how the physical world works. It's like a skateboard—it doesn't matter if you've read the manual; at some point, you have to get on the damned thing.

"A startling argument . . . provocative . . . absorbing." *–The Boston Globe*

T H E

H A N D

How its use shapes the brain, language, and human culture

FRANK R. WILSON

The Hand: How its use shapes the brain, language, and human culture, by Frank R. Wilson, M.D. Published by Vintage.

ashling
exercise Book

88 pages
Ruled Feint

name

subject

class

hanover stationery co. ltd
hanover quay dublin 2

made in ireland

Approved Quality
System

Ref. ASX8

Timothy O'Donnell

1995

PALE DRY

sketchbook

MUJI

ノート(横罫)

70

FIELD
NOTES

FIELD
NOTES

Note Book
Made in India

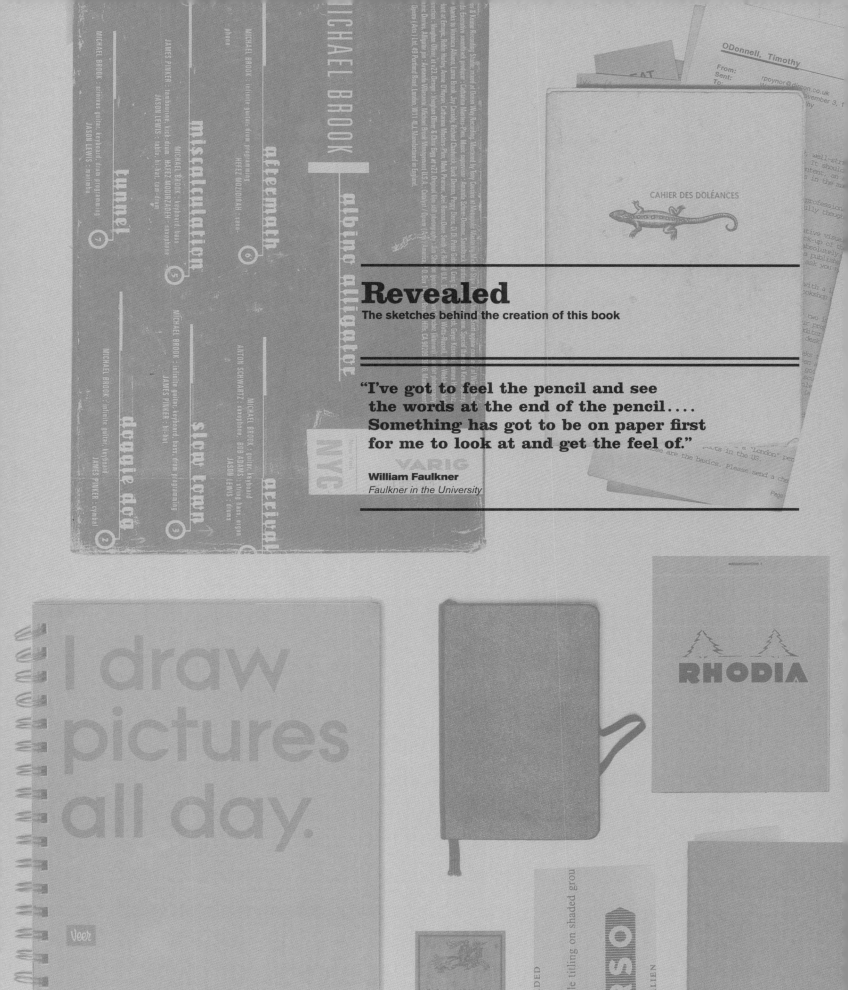

Revealed
The sketches behind the creation of this book

"I've got to feel the pencil and see
the words at the end of the pencil....
Something has got to be on paper first
for me to look at and get the feel of."

William Faulkner
Faulkner in the University

A brief
autobiographical note

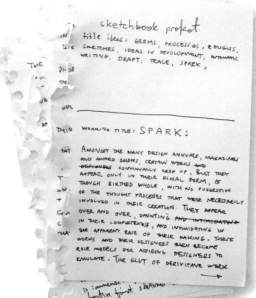

THIS BOOK STEMS from my own experiences as a design student years ago. On the whole, designers are avid collectors of inspiration, and few of my classmates' desks or dorm rooms were free from a colorful jumble of books, paper samples, and miscellaneous printed ephemera (in fact, I found those who didn't have any of this designer detritus lying around highly suspect.) Thus, whether slinking back to my dorm after a particularly demoralizing crit, visiting my girlfriend (also studying design), or pacing the studio at 3 a.m. in a frantic search for inspiration before exhaustion overtook me, I was always surrounded by visual stimuli—most often in the form of design books and magazines. I remember my friend John introducing me to the oversized Émigré in its corrugated cardboard mailer, or stumbling on 8vo's *Octavo* journal hidden away in the RIT library stacks. I received *The Graphic Language of Neville Brody* and other designer monographs for Christmas. These sources, in addition to my rapidly growing CD collection (fully one-third of my savings must have gone to the Lakeshore Record Exchange in Rochester), formed a second, and perhaps more important, design curriculum for me.

But what was I learning from these books? Flipping through the *Print* Design Annual while under a cloud of uncertainty about my own work mainly led me to conclude that there were some incredibly talented designers out there, and I was not one of them. Nor was there any reflection of my own fumblings in the assured pieces of design hung about the studio walls. Hearing your professor mutter irritably that you *still* haven't managed to figure out the gestalt principles and then raising your head to see one of Allen Hori's thrilling Cranbrook posters glaring down at you makes for a bad afternoon. A voice in your ear whispers, "Here is a real graphic designer, effortlessly juggling concepts you couldn't possibly comprehend. Why, you haven't even figured out the Law of Closure yet!" (The jury is out on whether I fully understand this even now.)

For years, I imagined an upper echelon existed where higher life forms lolled around on Eames lounge chairs and plucked fully formed ideas out of the ether. Eventually, I saw enough of the world to realize that even the design "stars" get blocked and occasionally experience self-doubt, and began to feel better about myself. But my creative struggles led to my interest in rough exploratory sketches and eventually, this book.

So it seems only fair that, tempting as it may be to pass off a 200-page book as just a little something I whipped up, then basking in your jealous admiration, I should share the physical evidence of the process I went through. At first, I was concerned that because I knew I would be publishing my sketches, I would intentionally make them look good and thereby strip them of any usefulness. I needn't have worried—having never designed or written a book before, and possessing a demanding full-time job, a growing family, and the unfortunate but unavoidable human proclivity for sleep, my sketches were done unselfconsciously, hurriedly, and truthfully.

—*Timothy O'Donnell*

SKETCHBOOK

- MUJI A4
- MOLESKINE
- BEHANCE

sketchbook:

pile of books

clarendon
+ rockwell
avld blg.

OVERVIEW

TITLE is a unique look at the doodles, rough sketches and comps that are the larger part of any design project. Despite the complete computerization of the field in the last 15 years, most projects are begun just as they were before — with pen and paper. These sketches can vary from tight comprehensive layouts to loose scrawls on the back of a napkin. In either case, they provide far more insight into a designers thought process and individual vision than do the reproductions of the final design which appear in the multitude of design monographs, articles and annuals.

The emergence of the internet computers has also while streamlining the process, brought the designers tools to the masses. Every office worker has a wide selection of typefaces to choose from, now many styles are almost clip-art + effects, and the advances in printing technology even (bestow) a professional quality to their efforts. With the design community, trends + stylistic elements are immediately adopted by countless designers, often obscuring the originators other 'signature'. Designers the world over are using identical software, even identical cuts of typefaces.

In this climate, a thumbnail-sized reproduction of a piece of graphic tells us next to nothing about the atmosphere + influences under which it was created. Design, divorced from any contextual information, For that, we need to look at the designer's sketchbook.

MARKET ANALYSIS

Primarily, the professional designer will be most likely to buy this book for its fresh angle on the creative process. However, students also will also be drawn to it — As a college student, I remember buying The Graphic Language of Neville Brody + being intimidated by the cohesive body of work, intellectual text, and complete dissimilarity with my own fumbling, trial-and-error process. In TITLE, students + professionals alike will have the opportunity to observe their heroes thought processes, take inspiration (that we all put our trousers on one leg at a time) from and be fascinated by the back-story of a project, and what different paths it almost took.

The multitude of books on design is a clear indication of the healthy market for this subject. Despite the increasing amount of titles

 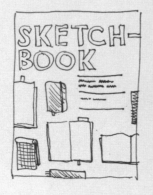

lined paper pattern

66

Candykiller 120
Coplin 122-125

First, I had to get a publisher interested in the idea. This notebook ended up containing various revisions of the book proposal. When I got bored of that, which was often, my mind would wander and I would start thinking about the cover. This was perhaps three years before Rockport accepted the book, so this is an egregious example of putting the cart before the horse.

Theoretically, the design isn't supposed to happen until after the content is finished. But as a designer first and foremost, it was often just too tempting to play around with the look of the book. I toyed with giving it a sketchy look, perhaps handwriting the headlines or printing the entire thing on lined paper, but in the end decided this bordered on pastiche—and besides, the books themselves were so rich, they seemed to call for a more restrained foundation to sit on.

Leaving your notebooks within reach can be dangerous—below, my 'in-house art director' seems to think the book needs more princesses in it.

Once the shock of having the book accepted wore off, things began to move quickly. A panicked call to friend and author Helen Walters soon saw us ensconced in a booth at City Bakery in New York, discussing possible contributors and eating cakes. This led to my waking up at least once a night with a brainstorm, terrifying my wife and daughter by shouting out "*Cornel Windlin!*" or "*Steff Geissbuhler!*" in the tiny hours before dawn.

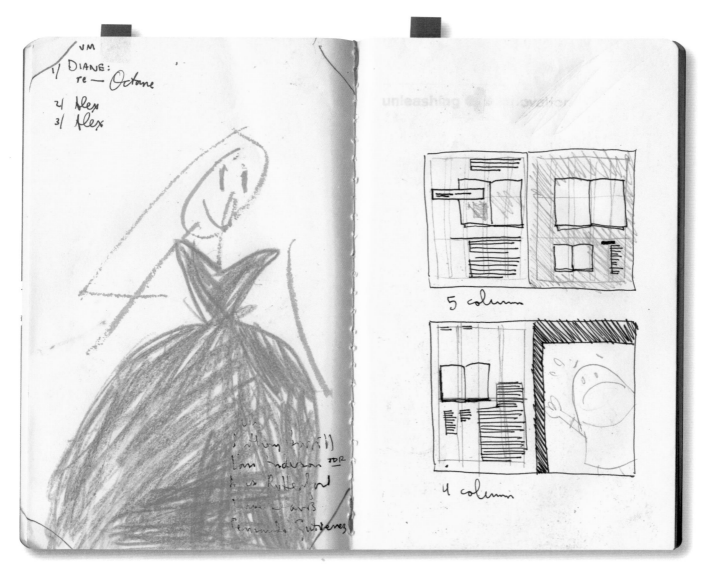

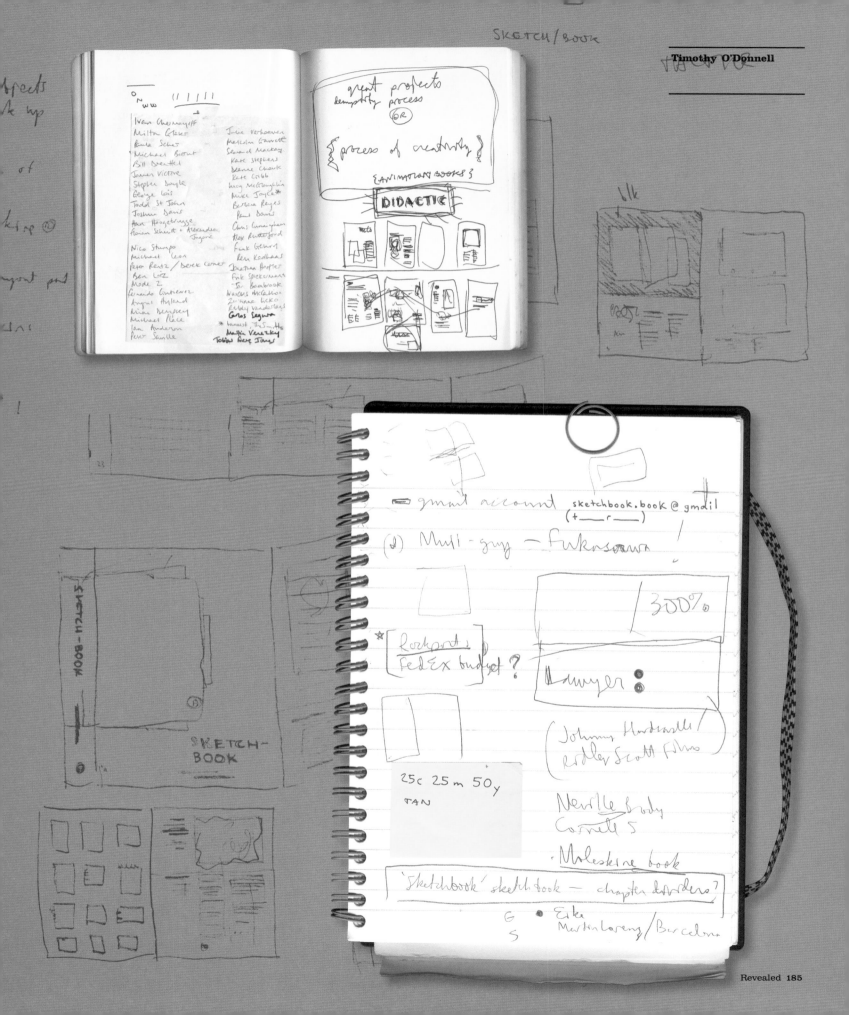

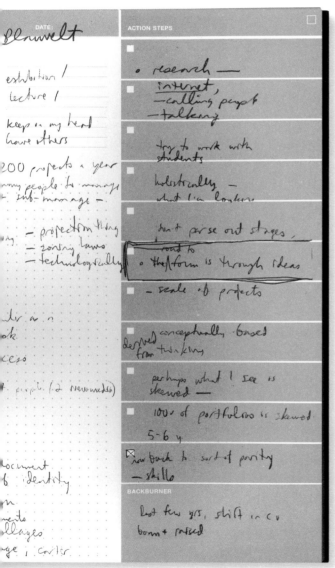

One aspect of writing the book that I ended up enjoying more than I anticipated was conducting the interviews. However, trying to arrange schedules, as well as ensuring I had everything I needed from contributors (signed paperwork, hi-res artwork, etc), became a logistical challenge that forced me to re-examine my own approach to organizing project notes—jottings in books of all shapes and sizes, strewn about my home and office. A *Behance Action Book* became the project bible, laden with interview notes, production notes, and to-do lists that stretched far into the distance.

Many of the most enjoyable discussions I had about the creative process had the misfortune to come from nonsketchers, which tended to limit their applicability to the book. Andrew Blauvelt of the Walker Art Center is eloquent (and funny) on the subject of creativity, but his in-house department's intense schedule—200 projects a year—means that despite his assertion that "the road to form is through ideas," by necessity he explores those ideas on the computer. "We use it as a sketch tool," he says. "That's what it's great for, creating variations. Sometimes I scrawl on a piece of paper, but it's not terribly meaningful. When you have more time, the context becomes larger, but with such a huge volume of work, the context is now!"

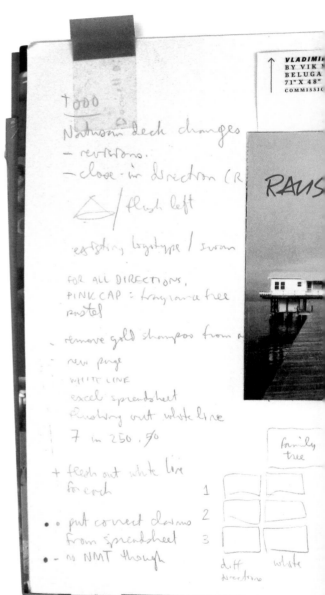

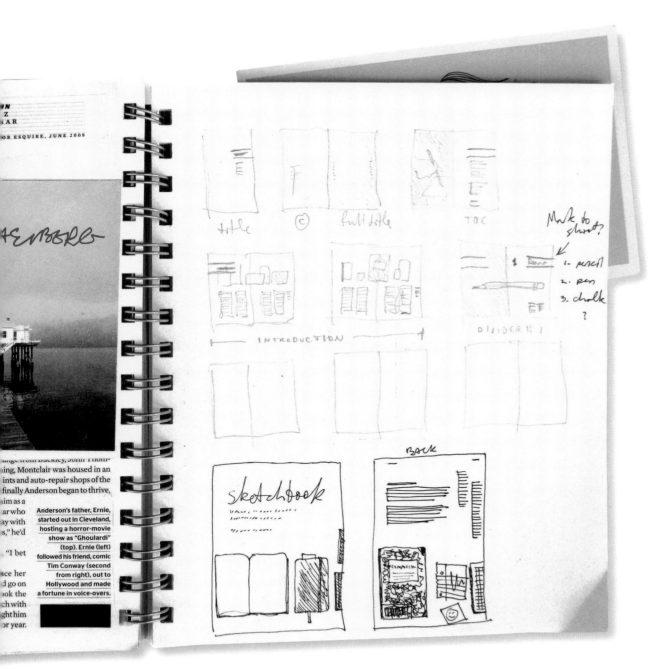

Ironically for a book about sketchbooks, once it was accepted by a publisher things began to move too quickly to afford much time for sketching. I was straight onto my laptop, working on the bus each morning and night, on weekends, evenings, vacation (grudgingly) and once, during a power outage at home, in a La Quinta Inn on Route 3—working in the bathroom so as not to wake my sleeping family. It's a glamorous life we authors lead.

Many of the sketches shown here were done when the project was still in its infancy. Perhaps in the end that is where they are the most useful; acting as a sort of net for that initial outpouring of enthusiasm. Should I open this InDesign document five years from now, what will it recall to me besides the labor involved—the late nights and the technical dificulties such as my curious inability to successfully set up automatic page numbers (at the time of this writing, this is a nearly 200-page book of page 16s)? Scrolling through this document, I'm looking for line breaks I should have fixed or grid elements that have slipped from their moorings. But flipping through my doodles and notes, all I seem to remember are the possibilities.

Directory

Marian Bantjes
bantjes.com

Gary Baseman/
HotChaChaCha, Inc.
137 N. Larchmont Blvd #129
Los Angeles, CA 90004
garybaseman.com

Michael Bierut/
Pentagram
204 Fifth Avenue
New York, NY 10010
T 212 683 7000
F 212 532 0101
bierut@pentagram.com
www.pentagram.com

Chris Bigg
29 The Strand
Ryde, Isle of Wight
PO33 1JF
T 01983 618713
chrisbigg.v23@btinternet.com

Ayse Birsel & Bibi Seck/
Birsel+Seck
1375 Broadway
27th Floor Penthouse
New York, NY 10018
T 212 965 9001
F 212 965 9002
ayse@birselplusseck.com
bibi@birselplusseck.com
www.birselplusseck.com

Davor Bruketa/
Bruketa & Zinic
Zavrtnica 17, Zagreb
10 000 Croatia
T +385 1 6064 000
F +385 1 6064 001
bruketa-zinic@
bruketa-zinic.com
www.bruketa-zinic.com

Stefan G. Bucher/
344 Design
344design.com

Ralph Caplan
rcaplan3@nyc.rr.com

Jamie Delaney
10–13 Thomas Street
The Digital Hub
Dublin 8, Ireland
T +353 (0)87 2488372
jamie@jamiedelaney.com
www.jamiedelaney.com

Stephen Doyle/
Doyle Partners
1123 Broadway
New York, NY 10010
T 212 463 8787
F 212 633 2916
doyle@doylepartners.com
www.doylepartners.com

Dave Eggers/
McSweeney's
849 Valencia Street
San Francisco, CA 94110
T 415 642 5684
www.mcsweeneys.net

Marco Fiedler &
Achim Reichert/
Vier5
139 rue Faubourg St. Denis
75010 Paris, France
T +33 1 42 05 09 90
F +49 721 151 48 22 83
contact@vier5.de
www.vier5.de

Paul Fuog/
The Co-Op
Level 6, 452 Swanston Street
Melbourne, Australia
T +61 39662 1657
paul@theco-op.net.au
www.theco-op.net.au

Johnny Hardstaff
c/o RSA Films Ltd.
42–44 Beak Street
London UK
info@johnnyhardstaff.com
johnnyhardstaff.com

Mar Hernández
aka Malota/
Malotaprojects
Calle en Bou, n° 4
1°, 46001,
Valencia, Spain
T 626587906
me@malotaprojects.com
www.malotaprojects.com

Nigel Holmes
205 South Compo Road
Westport, CT 06880
T 203 226 2313
nigel@nigelholmes.com
www.nigelholmes.com

Rian Hughes/
Device
2 Blake Mews
Kew Gardens
London TW9 3GA UK
T +44 (0)79796 02272
F +44 (0)208 896 0626
rian@rianhughes.com
www.devicefonts.co.uk

Mirko Ilić/
Mirko Ilić Corp.
207 East 32nd Street
New York, NY 10016
T 212 481 9737
F 212 481 7088
studio@mirkoilic.com
www.mirkoilic.com

Eva Jiricna/
Eva Jiricna Architects Ltd.
38 Warren Street,
Third Floor
London W1T 6AE
T +44(0)20 7554 2400
F +44(0)20 7388 8022
mail@ejal.com
www.ejal.com

Joris Maltha & Daniel Gross/
Catalogtree
www.catalogtree.net

Jason Munn/
The Small Stakes
3878 Whittle Avenue
Oakland, CA 94602
T 510 507 9466
F 510 336 1370
jason@thesmallstakes.com
www.thesmallstakes.com

Morag Myerscough/
Studio Myerscough
26 Drysdale Street
Hoxton
London N1 6LS
T +44 (0)20 7729 2760
morag@studiomyerscough.com
www.studiomyerscough.com

Richard Niessen/
Niessen & DeVries
Florijn 34
1102 BA
Amsterdam
T +31 20 6633323
richard@niessendevries.nl
www.niessendevries.nl

Frank W. Ockenfels 3/
Eye Forward
6311 Romaine Street
Los Angeles, CA 90038
purge@fwo3.com
www.fwo3.com

Left: a good samaritan's
note to Rian Hughes

Hello

I've taken good care of
your notebook while it was
left on my desk.
I didn't steal it like some
ghastly scoundrel.
Best wishes

See also

Sites of Interest
moleskinerie.com
moleskineproject.com
museumofnotebooks.blogspot.com
sketchbooks.org
rhodiadrive.com

Supplies
creativesoutfitter.com
exaclair.com
fieldnotesbrand.com
miquelrius.com
moleskine.com
muji.com
nightowlpapergoods.com
thedailyplanner.com
typotheque.com/diary

**Rob O'Connor/
Stylorouge**
57/60 Charlotte Road
London EC2A 3QT
T +44(0)207 729 1005
rob@stylorouge.co.uk
www.stylorouge.com

Timothy O'Donnell
sketchbook.book@gmail.com

**Pablo Rubio Ordás/
Erretres Diseño**
C/ Atocha 14
Madrid, Spain
T +34 913601136
F +34 913601137
info@erretres.com
www.erretres.com

**Sam Potts/
Sam Potts Inc.**
www.sampottsinc.com

**Mosato Samato/
Delaware**
delaware.gr.jp

**Daljit Singh/
Digit**
6 Corbet Place
London E1
daljit@digitlondon.com
www.digitlondon.com

Sterling Brands
Debbie Millman
350 Fifth Avenue,
Suite 1714
New York, NY
Tel: 212 329 4600
Fax: 212 329 4700
debbie.m@sterlingbrands.com
www.sterlingbrands.com

**Brian Taylor/
Candykiller**
www.candykiller.com

**James Victore
James Victore, Inc.**
36 South Street, D3
Brooklyn, NY 11211
james@jamesvictore.com
www.jamesvictore.com

Frank Wilson
handoc@mindspring.com
www.handoc.com

**Lance Wyman/
Lance Wyman Ltd.**
118 West 80th Street
New York, NY 10024
F 212 874 6814
l@lancewyman.com
www.lancewyman.com

Notes

1. "IDEO Selects: Works from the Permanent Collection," Cooper-Hewitt National Design Museum, June 22, 2007–January 20, 2008.

2. Dan Roam, *The Back of the Napkin: Solving Problems and Selling Ideas with Pictures* (New York: Penguin Portfolio, 2008).

3. Adrian Shaughnessy, *How to Be a Graphic Designer Without Losing Your Soul* (New York: Princeton Architectural Press, 2005).

4. Mihaly Csikszentmihalyi, *Creativity: Flow and the Psychology of Discovery and Invention* (New York: HarperCollins, 1996).

5. Saul Bass, *Essays on Design 1: AGI's Designers of Influence* (London: Booth-Clibborn, 1995).

6. Petr Kratochvil, "The Poetic Minimalism of Eva Jiricna," in *In/Ex-Terior: The Works of Eva Jiricna* (Prague: Techo, 2005).

7. Eva Jiricna, from "Architects' Sketchbooks," Victoria and Albert Museum website, http://www.vam.ac.uk/collections/architecture/architecture_features/essay_sketch/index.html.

8. Ayn Rand, *The Fountainhead* (Indiana: Bobbs Merrill, 1943).

9. Rick Poynor, *Vaughan Oliver: Visceral Pleasures* (London: Booth-Clibborn, 2000).

10. Michael Bierut, in *How to Think Like a Great Graphic Designer*, by Debbie Millman (New York: Allsworth, 2007).

11. Elements of the interview with Paul Fuog originally appeared on Lucy Feagins's Design Files blog (www.thedesignfiles.net) and are used with permission.

12. Philip Meggs, *A History of Graphic Design*, 4th ed. (New York: Wiley, 2005).

13. Vaughan Oliver, in *How to Think Like a Great Graphic Designer*, by Debbie Millman (New York, Allsworth, 2007).

Acknowledgments

An incredible number of people have encouraged and supported me during the creation of this book; I would rather it be remaindered immediately upon publication than to neglect to thank a single one of them. In other words, this is going to be long.

First and foremost, my love and profound thanks to my wife, Alex. Without her help at every stage, this book would never have happened. Few pages haven't been improved by her in some way.

Love and thanks to my mother, Eileen O'Donnell, for her generous and unwavering support (not just during the writing of this book but always) and my brother, Kevin O'Donnell. Thanks also to Armando Villasante, Gladys Villasante, and Anamari and Mladen Bulatovic.

Massive thanks to Helen Walters for moral support, sage advice, and generosity with her in-short-supply time.

I was fortunate to find a home at Rockport Publishers, where this book was lovingly and patiently (with a capital P) coaxed into being by my editor, Emily Potts; art directors David Martinell and Regina Grenier; Betsy Gammons, Madeline Perri, and publisher Winnie Prentiss. Thank you all for your enthusiasm and guidance throughout the process.

For invaluable input, advice, and friendship, my thanks to Bob and Colleen Shea, Roy Burns, Joyce and Mike Knievel, Maribel and Marcelo DeLeon, Michael Green, Katie Estes, Sarah Skapik, Carolyn Defrin, Will Thomas, Chris Hacker, Vaughan Oliver, Martin Andersen, and the patron saint of this book, Chris Bigg.

Thanks to all my colleagues at Johnson & Johnson for the interest they've shown, especially Stephen Bramwell, Elysha Huntington, Elizabeth Cory Holzman, Jeff Silva, Araba Simpson, Karin Taylor, Ravi Hampole, Taylor Leishman, Aimee Sealfon, Dustin Wagner, Cherith Victorino, Svenja Leggewie and Richie Tanaka.

For advice, assistance, or both, thanks to Kai Salmela, Cassie Brinen, Jen Simon, Deborah Adler, Gillian Gould, Yuka Hiyoshi, Susan Ledgerwood, Michelle Quint, Eli Horowitz, Barry A. Smith, Lee Iley, Sharon Chai, Bryan Bedell, Lucy Feagins, Jennifer Hsu, Jelena Mihelčić, Bradley Cho-Smith, Sherry Etheredge, Carol LeFlufy, Karin Mihatsch, Jee-eun Lee, Lynne and Richard Bryant, Zoe Antoniou, Stephen M. Kosslyn, Clifford Stoltze, Sylvie Agudelo, Rick Poynor, and Mark Sinclair.

Last but not least, thank you, Rowan, for being patient—yes, I can *finally* play ballerina/mermaid/princess with you now—and a loving welcome to Lyra Wren.

This book is dedicated to the memory of my father, Timothy George O'Donnell.

About the Author

Timothy O'Donnell's studies in design school switched from traditional methods to computer-aided techniques midway through the program. This brief but influential experience of the hands-on craft of design led him to join Vaughan Oliver's v23 studio in London, renowned for its expressive, organic work. After five years in England, O'Donnell returned to his native New York, where he has worked for MTV, Razorfish, and *New York* magazine. In each position, including his current role as Design Director for Johnson & Johnson's Global Strategic Design Office, he has strived to keep his life-long love of sketching and hand-lettering integral to his working process